BRITAIN IN OLD PHO

C000118648

NUNEATON MEMORIES

from the REG BULL COLLECTION

JOHN BURTON

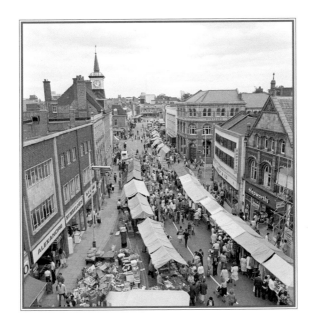

The History Press

For Sophie and her cousin Georgia

First Published by Sutton Publishing in 2004

Reprinted in 2016 by
The History Press
The Mill, Brimscombe Port
Stroud, Gloucestershire, GL5 2QG
www.thehistorypress.co.uk

© John Burton, 2004
Photographs © Warwickshire CRO

The right of John Burton to be identified as the Author
of this work has been asserted in accordance with the
Copyrights, Designs and Patents Act 1988.

All rights reserved. No part of this book may be reprinted
or reproduced or utilised in any form or by any electronic,
mechanical or other means, now known or hereafter invented,
including photocopying and recording, or in any information
storage or retrieval system, without the permission in writing
from the Publishers.

British Library Cataloguing in Publication Data.
A catalogue record for this book is available from the British Library.

ISBN 978 0 7509 3040 6

Typesetting and origination by Sutton Publishing Limited
Printed and bound in Great Britain

CONTENTS

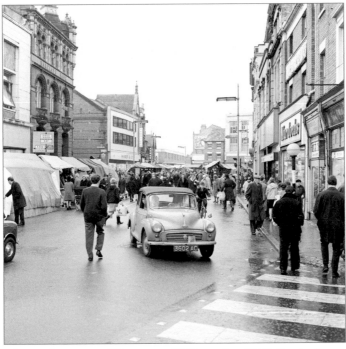

A wet market day in the centre of Nuneaton, 31 December 1966. Reg took many pictures of
the market, but he was usually looking from a top-floor window. This one, with a
Morris Minor and crowded street, is a particularly good example. *(2546)*

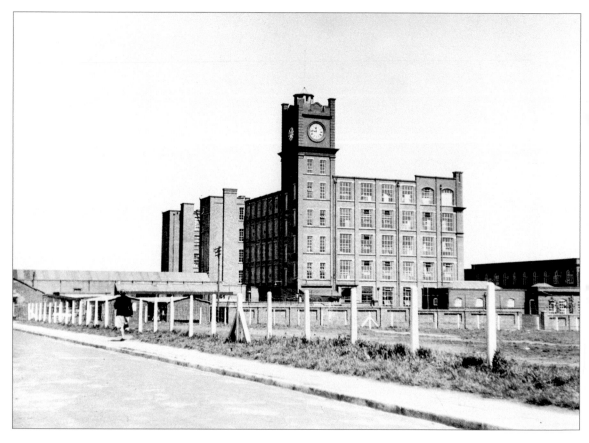

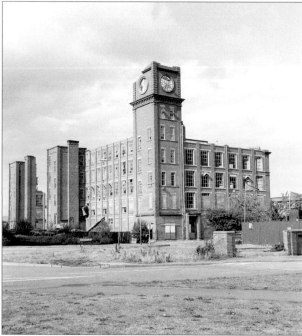

Change and continuity are themes of this book, though change will have the greater impact since Reg Bull was recording changes over a fifty-year time span that has seen more changes than any previous half century. Nevertheless there is also continuity. While the buildings in Nuneaton Market Place have changed, it remains the case that there has been a weekly market in that area for over 700 years.

The picture above is the earliest acknowledged by Reg as his own. It shows the Courtaulds factory in Marlborough Road in 1948 and was taken on a plate camera, possibly borrowed from his father. The picture on the left was taken from nearly the same spot in September 1995 and is one of the last in the collection. The factory, which had employed hundreds since its construction in the 1920s, lies derelict and vandalised. The clock has been removed and the demolition team has started work. Flats and houses now occupy the site. *(top: 8059; bottom: 7979)*

INTRODUCTION

Reg Bull was a quiet, unassuming, shy man. Born in Nuneaton in March 1927, he died in February 1999 aged seventy-one. His older brother Cyril was born in 1918 and died in 1984. Reg and Cyril were the sons of Horace and Gwendoline Bull. Their paternal grandfather kept the Weavers Arms in Abbey Street, and Horace took over and ran it until 1934. Early photographs show the boys in the back yard and garden of the Weavers Arms. In 1934 the family moved to 159 Edward Street, on the corner of Frank Street. Neither Cyril nor Reg ever married. Their mother died in 1959, aged seventy-one; their father in 1962, aged seventy-seven. After Cyril died in 1984 Reg, alone in a bigger house than he needed, moved to a smaller property in nearby Cheverel Street.

Reg and Cyril's maternal grandparents were Robertsons from Longford. Frederick Duncan Robertson founded the *Nuneaton Chronicle* in 1868 and ran it, and a printing business, until 1906, when he sold it to a company later owned by A.F. Cross. The

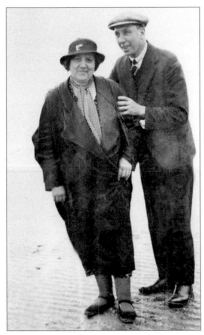

Reg's parents, Gwendoline and Horace Bull, on the beach in Wales, 1942. *(1214)*

The Weavers Arms in Abbey Street, Nuneaton, the early home of Cyril and Reg. *(box 150087)*

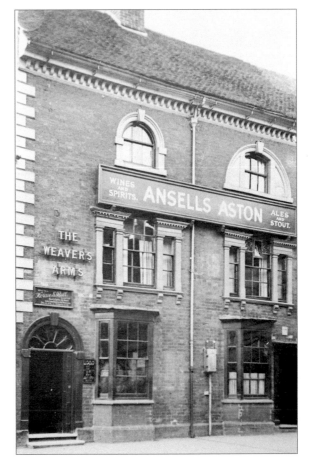

Robertsons had four children. Sidney ran the printing works, Frederick was a journalist with the *Nuneaton Chronicle* and later a well-known freelancer. One daughter married Mr H.J. Edmands of the Tower House in Bedworth, and the other, Gwendoline, married Horace Bull.

Cyril and Reg attended Miss Marriott's private school in Chapel Street and then King Edward VI Grammar School. Cyril became an accountant and spent his working life with the Council, serving in the Army Dental Corps between 1940 and 1946. Reg left school and started work as a clerk at Griff No. 4 Colliery in Heath End Road in December 1943. He did National Service with the Military Police, returning to Griff No. 4 before going to the NCB Area No. 4 HQ at Lindley Lodge on the A5 in 1951. In 1968 he went to the NCB Area Central Stores at Pipers Lane, Ansley. He retired early, in 1983.

Reg and Cyril were both shy men. Cyril was interested in cricket and cars. Between 1951 and 1983 he owned fifteen cars, usually trading up every two years. In 1951 he had a Vauxhall 12/6. He went on to own Hillmans, Sunbeam Rapiers, Humber Sceptres, Jaguar XJ12s and finally, a year before he died, a Vanden Plas Daimler. From 1976 he had a personalised number plate, CHB 59. How do we know these details? Because, although

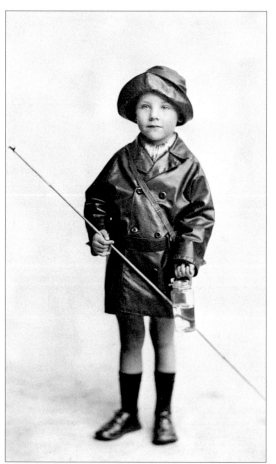

Reg ready for fishing. *(7872)*

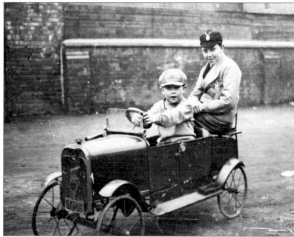

Cyril and Reg in a pedal car in the back yard of the Weavers Arms, *c.* 1932. *(box 150961)*

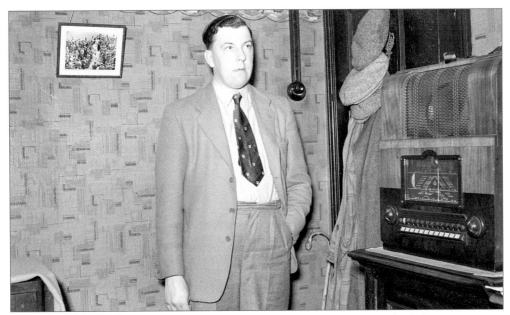

Cyril Bull, Reg's older brother, at home, 159 Edward Street, in May 1952. *(0291)*

Reg did not drive or own cars, he was always happy to photograph Cyril's, and he recorded all the details in the process. He photographed the new cars from all angles, and because both men were creatures of habit, they usually drove the latest car to Cloudesley Bush as a backdrop for photographs.

Reg had a lifelong interest in photography. His father had been a photographer, and his cousins Geoff and Ronald Edmands from Bedworth were both enthusiasts. Geoff, like Reg, was meticulous in keeping records of every photograph he took – date, exposure details, negative number and subject details. His great interest was transport and he had a large collection of railway and local interest photographs. Ronald was much more haphazard in his subject matter and record-keeping. He took photographs of anything that interested him.

Apart from his own huge collection of images taken over some fifty years, Reg also inherited his father's collection, some of them glass plates, and added work from other photographers. When E.V. Openshaw closed his studio Reg acquired all the negatives. There are thousands of anonymous group pictures, wedding photos, passport portraits on 6×9cm film, and amateur theatricals stored in boxes smelling distinctly of photographic fixer and residing

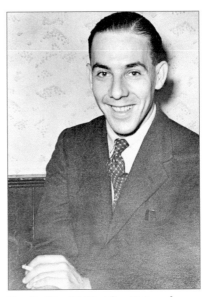

Reg Bull in 1949. After National Service he had returned to work in the offices of Griff No. 4 Colliery. *(8134)*

Reg Bull's darkroom, converted from a spare bedroom at 159 Edward Street. *(6729)*

in the vaults of the County Record Office!

It could have been a major task to separate Reg's photographs from all this clutter. But Reg aided historians and researchers by creating his own selection of his work, renumbering them and writing up the records. He did this at some stage in the mid-1990s and it was complete by 1997. Nearly every negative is on medium format roll-film, and each is stored in a proper negative envelope. Nearly every one is black and white and was processed by Reg in his darkroom. This 'premier league' of negatives is in ten shoe boxes. The details are in three hardback 100-page foolscap books, and there are nearly 9,000 negatives. It took three weeks to view each negative, and from those I selected some 500 for possible publication. These were gradually and painfully reduced to the 238 in this book.

I have selected pictures to illustrate the changes that have swept through Nuneaton since the Second World War. I chose only pictures taken by Reg himself. Like many local historians, Reg copied earlier pictures to add to his collection – postcards, posters, newspapers, other photographs. It is a future project to compile a book just from that material. But this book is designed to pay tribute to Reg Bull the photographer, to show evidence of his style, or voice, and to give credit for the numerous pictures he supplied to local newspapers, which have since been reproduced without being credited to him. This is not usually wilful. During the 1960s Reg provided pictures for the *Nuneaton Observer* and the *Evening Tribune*. Later he provided them for the *Nuneaton Evening Telegraph*. Over the succeeding years pictures circulate and their ownership is easily lost, especially as newspapers themselves have closed or changed ownership or personnel.

Thus most recent books on Nuneaton have used Reg Bull's photographs. Peter Lee is meticulous in crediting sources, but in his *Nuneaton* (Tempus, 2000) several pictures correctly credited to the *Coventry Evening Telegraph* (because it first published them) were actually taken by Reg Bull. Ted Veasey's *Nuneaton: A History* (Phillimore, 2002) uses two or three unattributed pictures that were by Reg Bull, and Roger Jeffery's *Images of Nuneaton* (Breedon, 1995) includes aerial pictures by him as well as a section called 'Ancient and Modern', which draws heavily on pictures not attributed to, but in fact the work of, Reg Bull. At least thirty pictures in the book were taken by Reg, and some of them appear again in this one. To ignore them because they had already appeared elsewhere would do an injustice to Reg. It is important for readers to see and recognise the scope and quality of his work and to know it was his. Reg was not keen on publishing a book of his own pictures. He was happy to provide them for local papers, or as a favour, but, ever reticent, he would have regarded a book devoted to his work as being a bit showy. He wouldn't have wanted a fuss.

Despite his shyness it is not possible to spend weeks with a man's photographs and not get to know him. There was nothing 'arty' about Reg. He was a craftsman, always striving

to produce a technically excellent photograph. Not for him the changing fashions of post-war photography. He wanted verticals to be vertical, composition to be conventionally correct, exposure to be accurate and details to be recorded. He used medium-format cameras (usually Rolleiflex, and after 1976 a wide-angle version) because the format gives marvellous detail, and black and white is best for archiving.

An analysis of the photographs in Reg's special selection shows that the most fruitful periods were the 1960s, with 2,625 negatives, and the 1970s, with 2,575. There were bumper years in 1963 (398), 1968 (424) and 1973 (470). The selection in this book concentrates on Nuneaton and its immediate suburbs, but it is important to say that Reg embraced much more than that in his photography. His interests changed over the years. In the 1950s he photographed cricket and cricketers at Edgbaston and Grace Road. In those days he could step on to the outfield and photograph county teams and players at will. Compton and Miller were but two great cricketers he photographed. In that decade, too, he photographed Nuneaton rugby games, but by the 1960s he was recording events at Nuneaton Borough Football Club.

Reg was fascinated by theatre and cinema. He idolised old variety stars like Stanley Lupino. He went backstage at Coventry Hippodrome to photograph stars like Norman Wisdom, Tommy Fields and Lupino Lane, and he often provided publicity pictures for local theatrical groups. In Nuneaton he haunted the cinemas as they were closed or were adapted for other uses. He photographed inside and outside, projectors and projectionists at the Scala, Hippodrome, Ritz and Palace. During the 1950s and '60s he recorded Nuneaton from the air, and flights took place in 1957, 1963, 1965 and 1966. He also used new, tall buildings as vantage points for taking shots.

He was interested in industrial activities, especially in Nuneaton, as they closed. He photographed divers working on underwater industrial projects in Sheffield and at Lots Road power station in Chelsea, as well as locally at Marston Jabbet. Like his cousins Geoff and Ronald he enjoyed photographing trains, railway stations, car rallies, vintage cars, aircraft and holiday trips. Such trips were limited. Despite Cyril's love of cars and Reg's love of photographing them, they only ever went on day trips. Only after Cyril's death in 1984 did Reg go away on longer holidays.

If we look for a more artistic side to his photography, there are delightful examples of countryside and canals, snow scenes and market scenes in Nuneaton – especially when

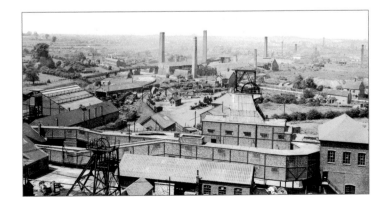

Griff No. 4, Heath End Road, Nuneaton, 1950. Tenlons Road and Ashdown Drive cover part of the colliery site today. Reg worked here before transferring to Lindley Lodge in 1951. *(0003)*

Reg Bull at his retirement party at NCB Pipers Lane, Ansley, 1983.

the market was over and only the detritus of a busy day remained. All artists find a voice – a quality that allows us to recognise their work and their style. A photographic voice is hard to produce, but Reg had one that reflects the kind of man he was, and the kind of equipment he used. There is a quality of quietness, of stillness in his work, a desire to record rather than to impose himself. He records rather than makes judgements. His accompanying notes do not bemoan the passing of old Nuneaton; they simply record it. Reg would be pleased to hear himself described as a photographer of record, and he did that superbly. His pictures of shopkeepers who were retiring or closing down in the face of redevelopment are straightforward portraits of people in their surroundings. They are in a neutral light, usually daylight, though he did use flash. When he attempted to take slightly more glamorous shots of receptionists or secretaries the photographs are stilted and contrived, stuck firmly in the 1950s.

One portrait of Reg sums up the sort of man he was, the background he came from and the period he lived in. It shows him paddling at the seaside. It was on a day trip to Brighton with Cyril in September 1977. Reg is sucking an ice cream out of deference to the seaside but he is paddling while still wearing his jacket and tie!

Nuneaton must be thankful that this unassuming man recorded so much over nearly fifty years. He missed some developments, as we all do. The huge Lexington Court development in Abbey Street was overlooked, as were most housing and industrial developments. But generally he could go out with his camera only at weekends, and there are restraints on your time when you use roll film and develop and print all your own work.

I am grateful for the opportunity to compile this selection of Reg Bull's photographs. It is a privilege for me, a fellow photographer, and I have enormous respect for his skill and knowledge. I am delighted that the book will bring his work to more people. On Reg's death in 1999 all his photographs were deposited with the County Record Office, and copyright in his work now belongs to them. I am grateful to Reg's friends Ruby and Geoffrey Atkins for their help and support, and to the staff at the County Record Office for their unfailing courtesy and help as they watched me work through the shoe boxes of negatives, squinting over the lightbox while simultaneously scribbling notes.

John Burton
August 2003

1 Post-War Austerity – the 1950s

(0018)

Many of the photographs in the next few pages were taken in 1951. The general appearance of the town is drab. There are very few vehicles around and where they exist they are not a challenge or a threat to pedestrians. A policewoman on a box is able to control the main junction. The threat to the town – and to every other town – was to come later, but it begins to show itself in the selection of photographs taken in 1959. By then the country was coming out of austerity, rationing had gone, and people had some spare cash. Credit was more readily available, and ordinary people were hoping to buy or rent televisions. Some even aspired to a car. By the end of the decade we see evidence of Vicarage Street being widened between Church Street and Leicester Road. Forty years later it is being widened again in 2003 and 2004.

In the 1951 pictures much of the town looked as it had before the war. During the next few years spirits were raised by the Festival of Britain in 1951 and by the coronation in 1953. Within a decade we notice many new furniture shops in the town centre. Grocery shops still sold most of us our provisions and most street corners still had either a corner shop or a pub.

The picture above was taken in August 1950 in Coton Road. On the right is part of the Midland Red bus depot. The chimney belongs to the Electric Light Company (some of their buildings are still in use as Council offices) and the side of the Council House (now Town Hall) is on the left. The splendid street lights were soon to be replaced by concrete and sodium, and you could have a day in London on a British Railways August excursion for 13s 6d. The chimney was demolished a month later.

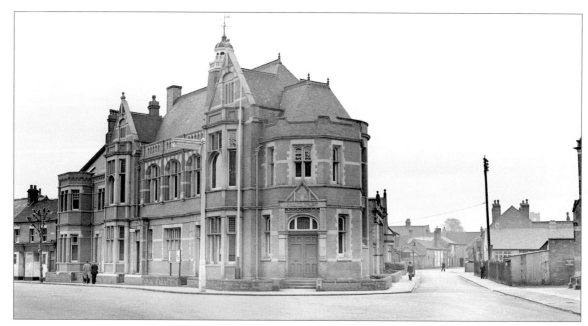

Two fine buildings shown here on Sunday, 20 May 1951. The police station and courts (above) date from the turn of the century. It still looks good, even with extra windows in the roof, and the jail house behind it in Chapel Street has made a good pub and restaurant. All the other buildings in Chapel Street have gone over the last thirty years, and replaced by Ropewalk shopping mall. In 1951 the Council House, now Town Hall (below), was less than twenty years old and had many fewer employees than now. The floral decorations that now enhance the town had yet to be introduced. *(top: 0098; bottom: 0099)*

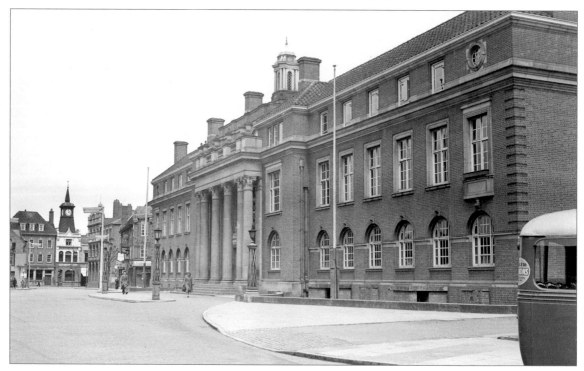

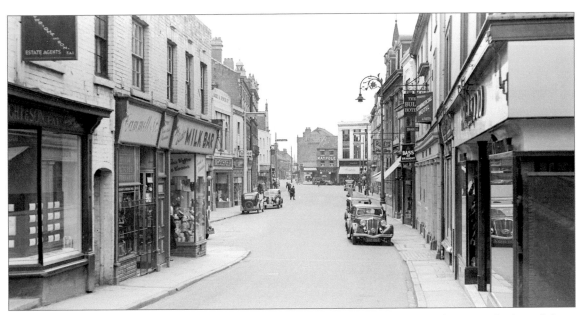

Bridge Street, looking into the Market Place, Sunday, 20 May 1951. Over the next few years the line of shops on the left was to go and the road widened. On the right is one of the pre-war lamp-posts with its ornate ironwork so clearly visible on early Nuneaton postcards. On the left-hand side can be seen the new sodium lights. The Milk Bar was a popular venue, increasingly so later in the 1950s, when rock and roll arrived and teenagers were discovered. *(0093)*

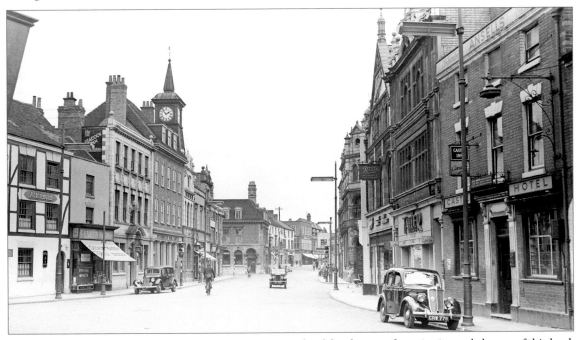

The Market Place, Sunday, 20 May 1951. It is one example of the themes of continuity and change of this book that we recognise immediately this scene in the centre of Nuneaton. On the right the Castle Hotel and Tatler buildings have gone, as have The Board and Masons on the left. Yet, in some form or other, practically every other frontage shown here still exists. *(0095)*

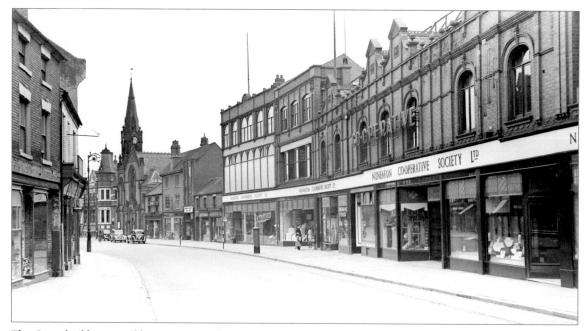

The Co-op buildings in Abbey Street, Sunday, 20 May 1951. Again the scene is immediately recognisable, though the Co-op has moved out of the nearest units, and the church and adjacent shops and pub have been redeveloped. The cars in the distance may have belonged to the better-off members of the Methodist church on that Sunday. Despite the attention of the typical 1950s family (father in suit, mother and daughter in Sunday best frocks), the Co-op windows do not look terribly exciting. Sadly this Co-op closed in June 2016. *(0094)*

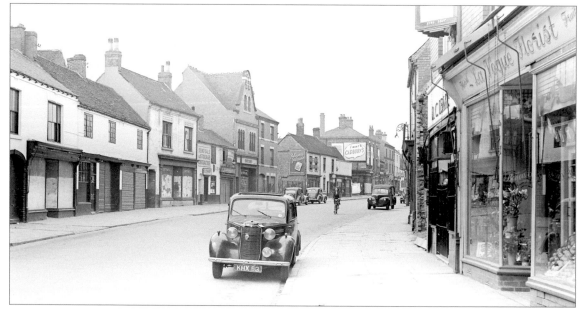

Abbey Street, Sunday, 20 May 1951. Reg Bull had turned and faced up Abbey Street after taking the picture at the top of the page. On the right is Leake the jeweller (still there). All the buildings on the other side of the road have gone, to be replaced by the Century Way car park. The building in the distance with the Cadbury advertisement was Ranby the chemist; it came down to make way for the Roanne Ringway. *(0097)*

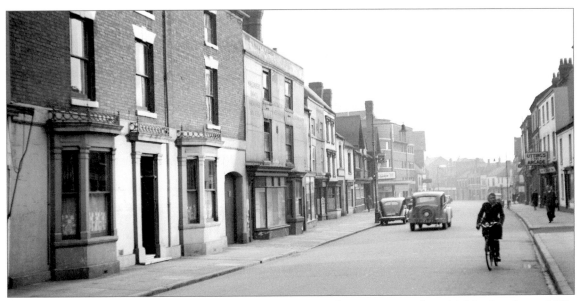

Abbey Street, often called Upper Abbey Street, Sunday, 9 December 1951. In the middle distance, on the left-hand side, is the Ritz cinema. This side of it is the Coach and Horses. All the buildings on the left have gone. Indeed they went soon after Reg took the picture, and later the enormous Lexington Court flats complex was built. The fine double-fronted house on the left was Dr A.A. Wood's surgery in the 1930s. *(0196)*

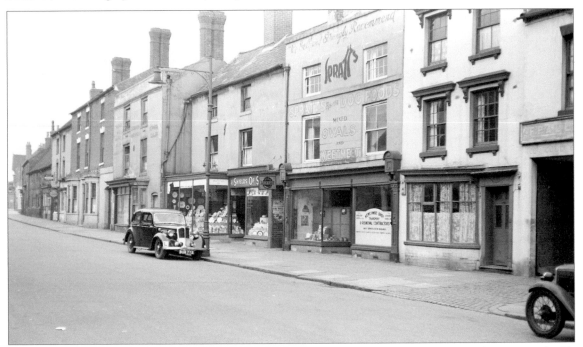

Nearer to the Coach and Horses and looking up towards Abbey Green, Sunday, 9 December 1951. Shields crockery shop and Newcombe's removal contractors feature here. Don't we all remember that cute little dog advertising pet food? On the extreme right is part of Frank Palladino's ice cream parlour. It was dispensed from a large tub on a cart pulled by a small donkey; when it died, Frank sold ice cream from the front door. *(0194)*

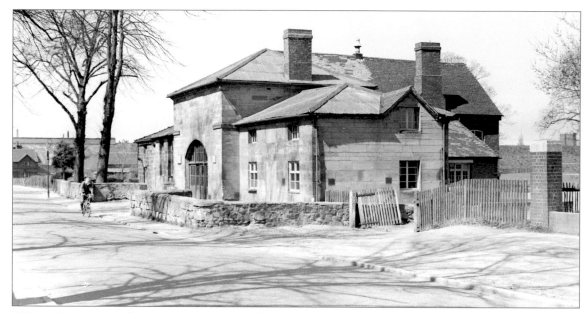

Chilvers Coton Free School, Avenue Road, Sunday, 22 April 1951. This building has had several close shaves in its long life. The far end was the original school for poor children of the parish provided by the Newdigate family in 1735. It was extended to keep pace with the expansion of education. It lost most of its roof when Coton parish church was destroyed during the war, and this photograph shows the temporary replacement roof, which was replaced in 2011. In the 1980s it was nearly lost to a road scheme, but is now listed and in use as a heritage centre. It is one of the oldest surviving buildings in the town. *(0083)*

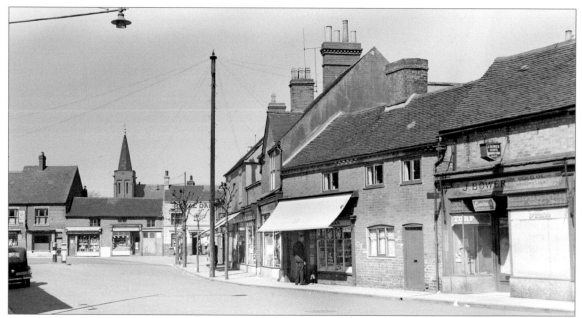

Attleborough Green, Sunday, 22 April 1951. The centre is almost deserted. The Royal Oak seems to be open, but little else. A sign on the wall of one of the shops says 'National Health Insurance Dispensary'. The NHS was only three years old, and the concept of free prescriptions was still a novel one. Looking at this selection of Sunday pictures in 1951 reminds us how boring Sundays often were during that decade. *(0082)*

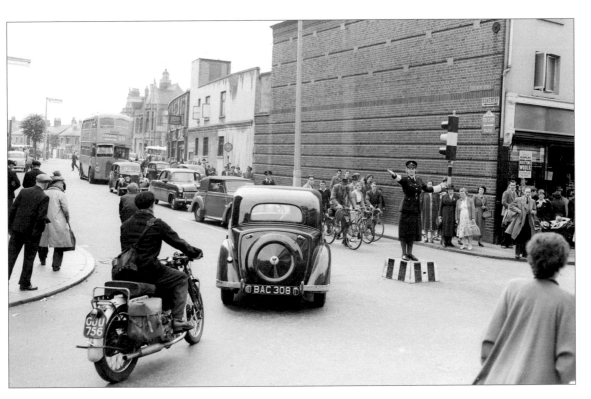

Above: Coventry Street from the Market Place, 1953. There was enough traffic to need the occasional attention of a police officer. Unusually for Reg Bull, this photograph was not taken on a Sunday, so it shows a busy day with cyclists, pedestrians and vehicles. The motorcyclist was not encumbered by a helmet. The notice in the window of Woolworths announces a special display of knitting wools. *(box 12-022)*

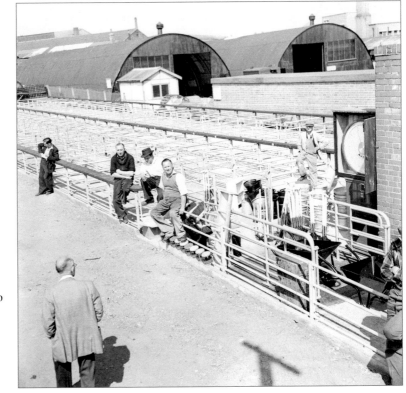

The livestock market was in Harefield Road, behind the Newdigate Hotel and opposite the bus station. The regular market would bring farmers into town and the pubs had special opening hours to accommodate them. Changes in agriculture since the war have destroyed that way of life.
(box 12-106)

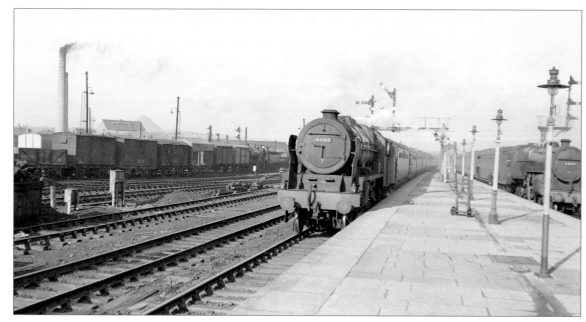

Steam was still ruling the railways when this photograph was taken on Saturday, 25 October 1952. It shows a class 6P Royal Scot No. 46160, *Queen Victoria's Rifleman*, arriving at Nuneaton Trent Valley station with the 11.00 a.m. from Euston. *(0321)*

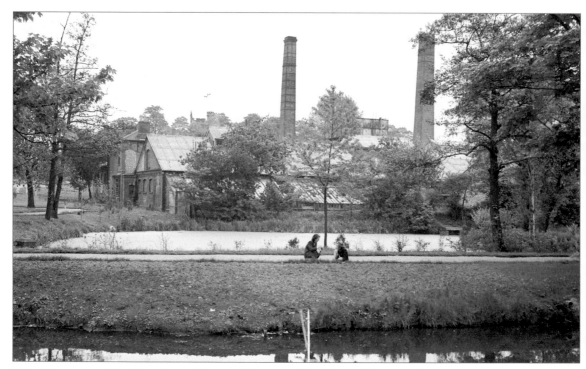

This picture was taken from the newly created Memorial Garden at the rear of the museum. It looks across the river and the lake to the Union Wool and Leather factory. The site is now occupied by Sainsbury's and its car park. St Nicolas' church tower can be glimpsed behind the buildings. *(0390)*

This superb photograph sums up much of what the early 1950s were about. It was taken on Sunday, 30 March 1952. What lifts it from the good to the superb is the fact that Reg Bull waited for the solitary figure struggling through the snow before he took the photograph. The early 1950s saw fuel shortages, badly insulated houses with no central heating, and some items still rationed after the war. The bus stop is in front of where the fine buildings in Church Street once stood; these had been bombed during the war and their back gardens were about to be made into the George Eliot Memorial Garden. The picture below was taken from the same spot eight years later, on Saturday, 13 June 1959, a particularly hot summer. The temporary prefabricated shop units are nearing completion and there is a temporary bus stop sign. The units are still there fifty-seven years later. *(top: 0235; bottom: 0929)*

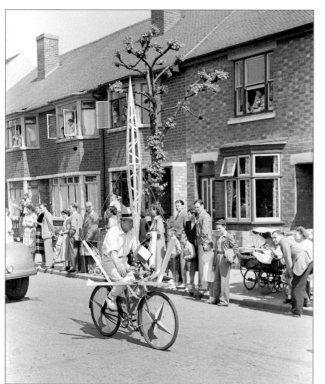

The year 1951 saw the defeat of Attlee's Labour Government, which in six years had changed the political and social face of the country, nationalising the coal industry, founding the NHS and implementing Butler's 1944 Education Act, to name a few. The Festival of Britain was an attempt to blow the trumpet for Britain, cheer people up and inspire effort for the future. The two pictures here were taken at the Festival of Britain Gala Day Procession in Manor Court Road on Saturday, 2 June 1951. The cyclist had made his bike resemble the Skylon, a big feature at the Festival in London, and he has the Festival symbol or logo on both wheels.

The picture below shows a Western Stage Coach entered by three local cinemas. The banner on the side reads 'Transport of the past. Your entertainment for the future at the Tatler, Scala, Palace'. *(left: 0113; bottom: 0112)*

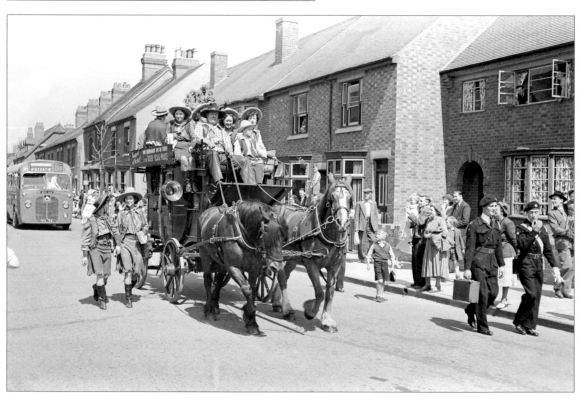

After the war there were discussions about commemorating George Eliot by creating a garden or public open space in her honour.
Some suggestions were very ambitious and came to nothing, but the hospital took her name in 1950, and in 1948 the idea of a special garden alongside the river using the land behind 'Lawyer Dempster's' house had been suggested. An appeal was launched in January 1951 and a competition was organised by the Institute of Landscape Architects to design the garden. The results are shown in these two pictures, taken on Sunday, 15 June 1952, just six weeks after the official opening. The picture on the right shows the water feature in the foreground with the Flour Mill behind. The lower picture shows the whole design, won by Mary Braendle and Ronald Sims. The extended Vicarage Street had not yet been built, but beyond the wire fence can be seen a bit of the Union Wool and Leather building. The enclosing wall to the feature was demolished only in 2001. The Council missed an opportunity to celebrate the garden's golden jubilee in 2002, when the new bridge opened adjacent to the George Eliot obelisk. *(right: 0303; bottom: 0302)*

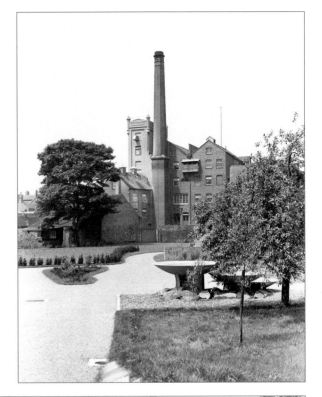

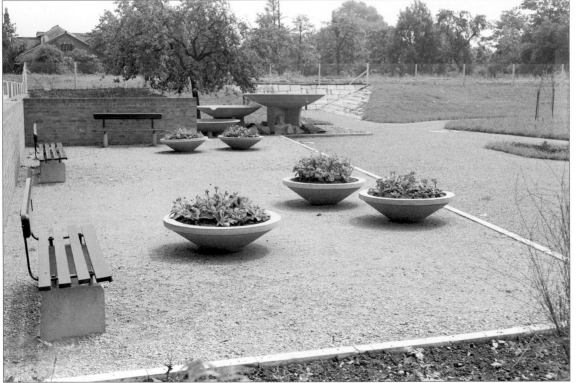

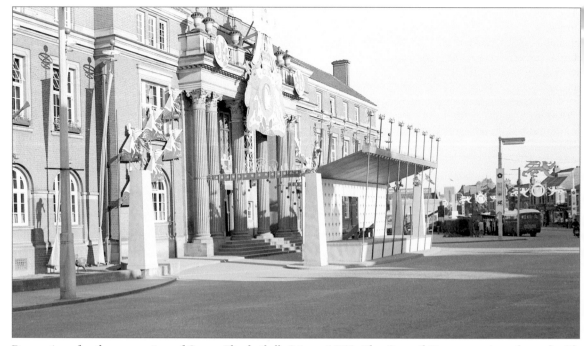

Decorations for the coronation of Queen Elizabeth ll, 2 June 1953. The Council House was transformed with huge decorations and a stage facing Coton Road. Large decorations straddled the roads and shops competed to produce lavish displays. For the 1977 Silver Jubilee the Council House was decorated only with a few long banners between the pillars, and by 2002 the Golden Jubilee was greeted at the Town Hall with studied indifference. Whether that displays republican tendencies among our councillors or changing attitudes to the royal family by the general public is an interesting point for discussion. *(0420)*

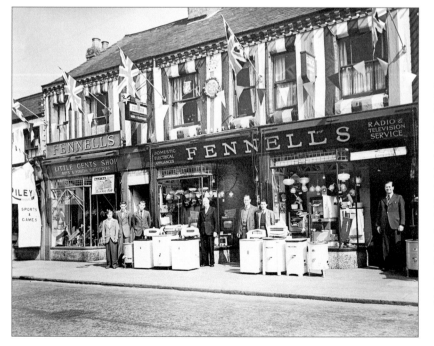

Coronation decorations at Fennell's in Queens Road. They are showing the latest in consumer desirables – washing machines, Ekco televisions, food mixers and light fittings. Next door is the Little Gents Shop. Just imagine taking today's boys to a 'Little Gents Shop'. Over the door is a poster for the Nuneaton Amateur Operatic production of *Merrie England*, a suitably patriotic choice for the times.
(box 15-1054)

The Memorial Garden behind the museum commemorates Nuneaton's dead in the Second World War. The little building shown here housed the book of remembrance. The picture was taken on Sunday, 24 May 1953. The building suffered from vandals over the years and in 2000 the Warwickshire Regiment raised money to redesign the memorial, remove the gates and roof and create a place for quiet reflection. It works well. *(0389)*

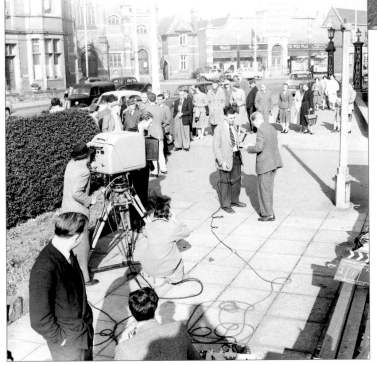

The coronation was a time when many families bought television sets, though there was only BBC to watch and much of the day was devoted to the test card! 1955 saw BBC's classic spoiler, when Grace Archer perished in a fire on the night ITV opened. One very popular show was *Tonight*, fronted by Cliff Michelmore, and in October 1957 the *Tonight* team, with Geoffrey Johnson Smith, came to interview councillors offended by an earlier unflattering report on Nuneaton by Slim Hewitt. One is impressed by the size of the camera and the fact that the cameraman wears his hat during filming. *(box 12-147)*

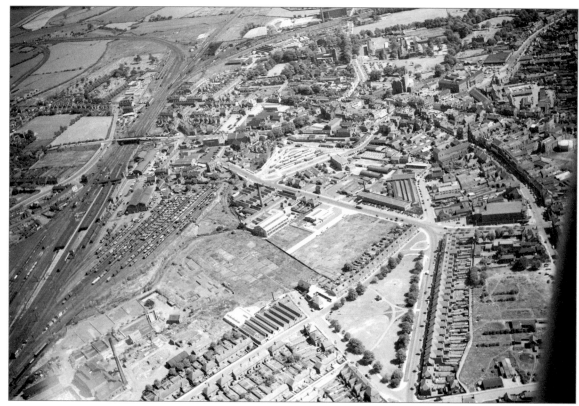

On Saturday, 15 June 1957 Reg Bull hired an Auster aircraft and took his first selection of aerial photographs. The picture above shows part of the town that has changed dramatically. All the railway marshalling yard has gone, to make way for Asda and its linked edge of town shops. Biddle's factory has gone. The large building, centre right, was the Ritz cinema; now a bingo hall. To its left now is the Millennium fountain. *(0725)*

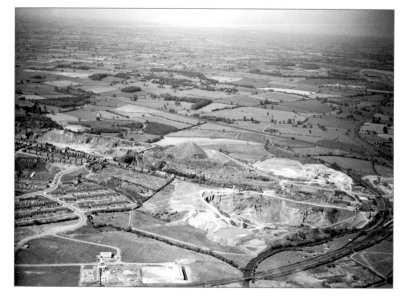

This fascinating picture is looking down on the quarries at Tuttle Hill. The spoil heap (Mount Jud) and quarry are centre right. Bottom right is the Abbey Street station and the canal, and behind it the Midland Quarry, which in 2003 has been partially emptied and filled in, to prepare the site for major housebuilding and a marina. Bottom left is the recently built area of Camp Hill around Hilary Road and what is now the Pool Road Industrial Estate. By 2020 this area will have changed beyond all recognition, a fact that makes the photograph particularly interesting. *(0726)*

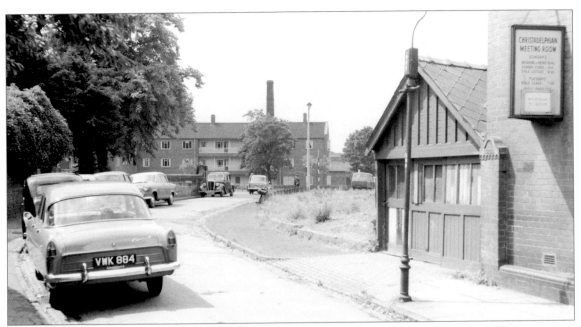

There are significant changes in these 1959 pictures compared with the 1951 set. The cars are now more modern. The Ford Consul and its many imitators are clearly a post-war design. In 1959 a major road construction started in the town. Vicarage Street was widened and a roundabout at the Church Street junction constructed. Part of the churchyard was taken to enable this to happen. The picture above, taken on Saturday, 27 June 1959, shows the course the new wider road will take. The Christadelphian Meeting Room on the right is still there. The picture below, taken a fortnight earlier, shows the half-demolished back of the Black Horse pub in Wheat Street. Percy Grant of Stoney Road, foreman, is using the theodolite and Martin Connelly from Birmingham holds the staff. All the houses behind him were to come down for the new police station. After forty-five years the same road was widened again, and another new justice centre was built on the left-hand side of the road. *(top: 0935; bottom: 0925)*

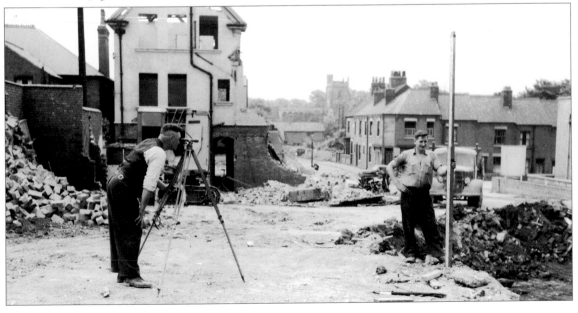

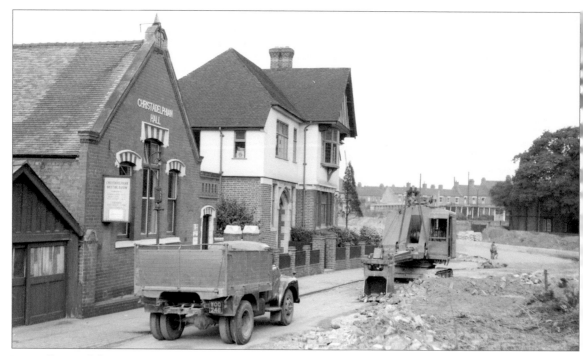

Reg Bull visited the site again three months later and both photographs on this page were taken on Saturday, 26 September 1959. Both buildings are still there, but the Vicarage Street school, partially visible among the trees on the right, has been demolished. *(0958)*

The clue here is the church tower. There is netting round the section of the graveyard that was being moved. The buildings shown are in Church Street and they were demolished to make way for the new library. In fact, the library was built behind them to give the open space and flower beds that are still a feature. *(0962)*

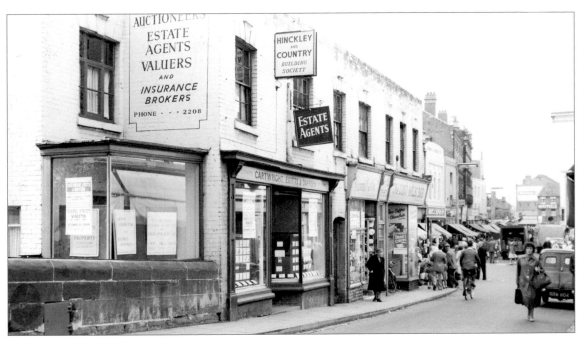

Both these pictures were taken on Saturday, 27 June 1959. Reg Bull took them because the line of shops was to be demolished and the building line pushed back to widen Bridge Street. The notices in the windows of Cartwright, Evitts and Daffern point to a new temporary office in Chapel Street, from October 1959. The Lido Milk Bar will go and Cammell and Co. advertise a removal sale. The picture below shows the same line of shops taken from the Market Place end of Bridge Street. In the far distance is one of J.C. Smith's stores in Church Street, which would also soon disappear. *(top: 0949; bottom: 0948)*

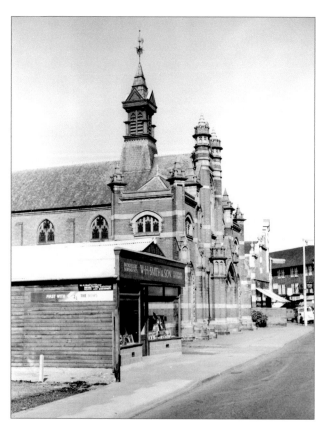

By 1959 it is clear that change was on its way and these last few pictures are a preview of what was to come in the 1960s on a greater scale. One of the shops affected by redevelopment in Bridge Street was

W.H. Smith. The picture on the left shows their temporary shop in Chapel Street, next to what is now the United Reformed church. The picture below is only a few yards further up Chapel Street and shows the temporary office for Cartwright, Evitts and Daffern, the estate agents and auctioneers. The open space was the old council depot yard. It is still open space – a car park, but by 2005 it will be part of The Ropewalk shopping development.

Both the pictures were taken on Monday, 28 September 1959.
(left: 0964; bottom: 0963)

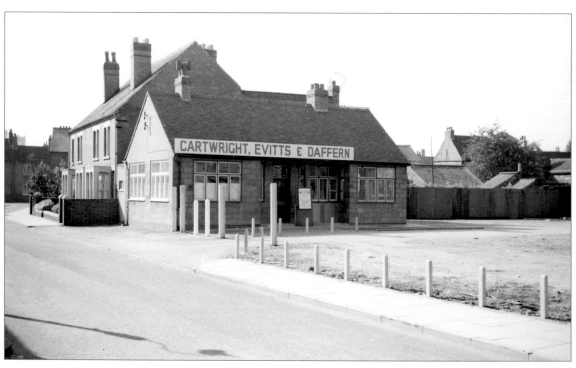

2 Destruction & Reconstruction – the 1960s

(0970)

It is a truism beloved of politicians, and therefore suspect, to say that the 1960s were the cause of all our subsequent ills. For many the decade was liberating after the stultifying 1950s. It saw the rise of consumer power, the transformation of popular culture through pop music, the arrival of inexpensive but exciting fashion for all, a revolution in what television could achieve, and a determination to bring greater opportunities through comprehensive and then higher education. It was also a decade of full employment.

What the decade also saw was the inexorable spread of the motor car. We all wanted one, and existing roads and towns could not cope. So the decade produced most of the early motorways. This has altered employment opportunities radically. The desire by ordinary people to have cars has bedevilled town-centre planning ever since. It has led to out of town shopping malls and the demise of most corner shops. It has led to the wholesale destruction of vast tracts of towns to provide wider, or new roads. It has also, ironically, led to pedestrianised town centres as the only way to give back space to people on foot.

The 1960s also saw a vast rebuilding programme. There were some excellent new buildings – notably in the new universities. But hindsight shows that there were some execrable ones – cynical, cheap and inappropriate. Tower blocks for mass housing were also a feature of the 1960s, and their cheapness and nastiness haunt us still in alienated and disaffected communities.

In Nuneaton we see all these developments in microcosm. At least Nuneaton has kept its old street pattern, unlike Bedworth, which was virtually redesigned. But there was hardly a street or road in Nuneaton during the 1960s that did not see some demolition and reconstruction – as the following pages show.

The picture above shows Nuneaton Market Place in September 1959. Once-familiar shops are here – Weaver to Wearer and Murdochs, the Maypole and in the distance the mighty Burton's, whose distinctive art deco shopfronts graced every high street in the country. On the road is a Triumph Herald, which, with the Ford Anglia and the Mini, brought affordable motoring to so many during the 1960s.

We have already seen the widening of Vicarage Street between the church and Leicester Road. This photograph was taken in March 1960 and shows a completely new road under construction between Coton Road and Church Street. When we recall the amount of traffic using it every day now, it seems strange to think it is only just over fifty years old. It was part of an inner ring road designed to keep traffic out of the town centre. The next chapter of this book records the completion of the ring road in the 1970s. *(1007)*

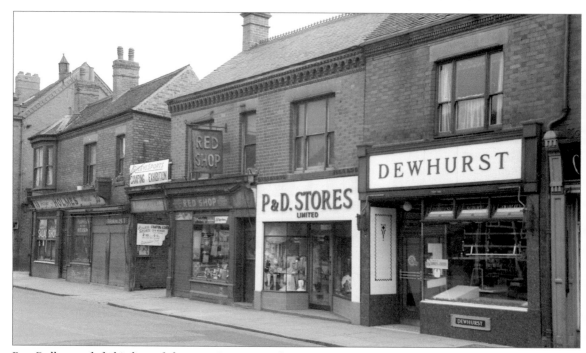

Reg Bull recorded this line of shops in Queens Road, opposite Stratford Street, on Thursday, 12 April 1962. Holmes the fruiterer and florist is advertising salad in the window. The Red Shop is a well-remembered hardware store, and P & D Stores was a ladies' clothes shop. Within a few years all were demolished. *(1040)*

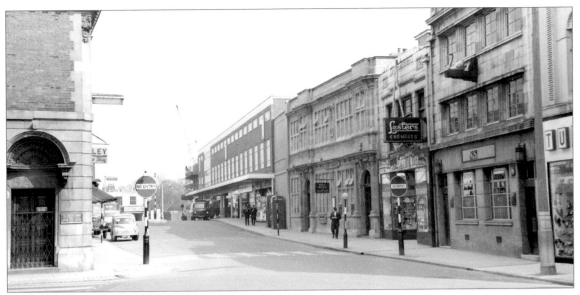

Bridge Street from the Market Place, Thursday, 12 April 1962. The new buildings in the distance have replaced those shown on page 27. Reg Bull took this view because he knew that the nearer buildings – the White Swan, Lesters and the post office were scheduled for demolition. One bemoans their passing since they seem to be above average buildings for a town like Nuneaton, certainly more interesting than the new ones beyond them. A rhetorical question, but why have we in Britain allowed so many magnificent post office buildings to be lost? A really important part of our cultural heritage has disappeared with barely a murmur. *(1043)*

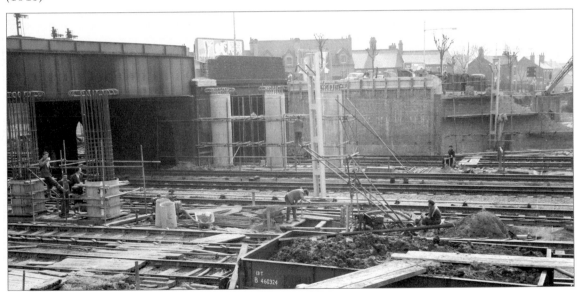

Where once the railways carried all before them and cut their way through swathes of town and country with little regard for the existing landscape (imagine what locals said when Coton Arches were built and when Weddington and the Hinckley Road were cut off by the railway!), a century later the roads did exactly the same, destroying communities with six-lane highways (Birmingham, Hammersmith, Coventry spring to mind). In Nuneaton traffic congestion forced the widening of the Leicester Road bridge over the railway, seen here on Thursday, 12 April 1962. *(1044)*

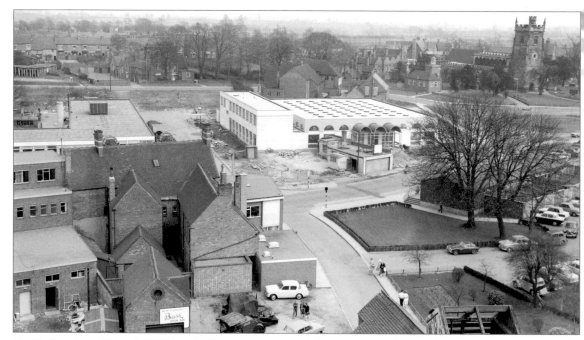

On Wednesday, 25 April 1962 Reg Bull went to the top of the Nuneaton Flour Mill (see pages 19 and 21). The picture above looks down over Church Street to the new library. Some of the original line of property remains. Behind the library space is cleared for the new magistrates' court and police station, and on the other side of Vicarage Street is the school. Turning to his right Reg then looked down over the George Eliot Memorial Garden, opened ten years earlier. The new road certainly looks very new and the churned-up embankment reminds us of similar disfigurement in 2002–3 as the road bridge was renewed in preparation for a wider road. The George Eliot obelisk is on the lower right edge of the picture. *(top: 1062; bottom: 1071)*

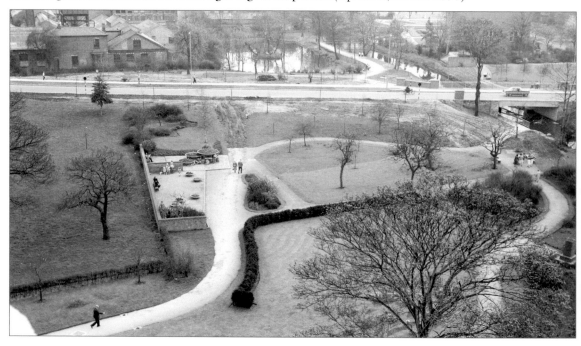

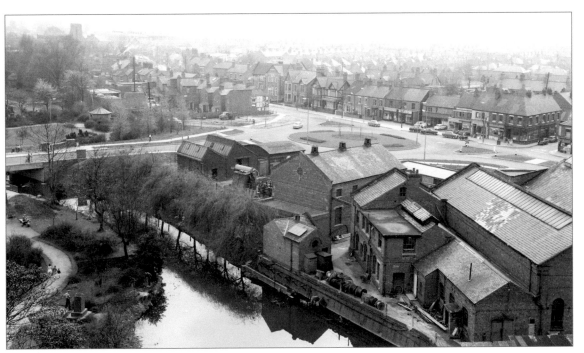

Turning further to his right again, Reg looked down over the river, the old electricity station and the new roundabout in Coton Road. The continuation of the inner ring road, now Roanne Ringway, was still a plan, but on the right can be seen the houses and shops that eventually made way for it. The 2002 Jubilee Bridge has been built at the bottom of the picture. Behind the George Eliot obelisk men are working, clearing up the site after felling a tree. *(1068)*

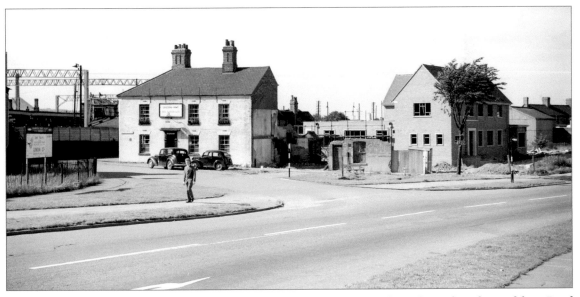

The old and new Graziers' Arms. The position of the old pub recalls pre-railway days when the road from Bond Gate would have come past it. The new pub fronts the realigned road. The gantries for electrification can be seen on the left and the advertising board offers a day return to London for 23s – quite an increase from the 13s 6d in 1950 (see page 11). This picture was taken on Sunday, 9 September 1962. *(1125)*

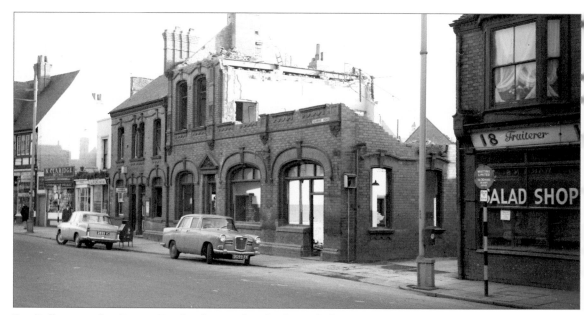

Reg Bull returned to Queens Road eight months after he took the picture on page 30 to record the demolition of the building that had housed the library, and before that the council offices. Holmes the fruiterer is on the right. The building on the left of the picture was the Red Lion, shown again later. *(1202)*

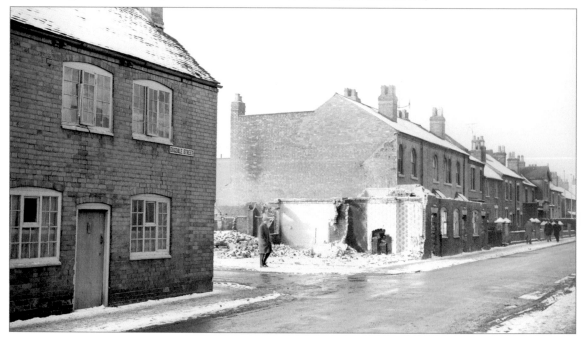

Dugdale Street photographed during the very long snowbound winter, Sunday, 3 February 1963. Reg took many pictures in this part of town, since he lived so close to it. The area now is mainly car park and inner ring road, with Ropewalk shopping mall. But it is easy to see where the roads once lay. Dugdale Street is a good example. Shown here is the junction with Windsor Street. Today this section of Dugdale Street is lost in car park and ring road, but it can be picked up again alongside what was the Harcourt pub and is now flats, and continues until it meets Riversley Road. *(1228)*

Baker's Dispensing Chemist, Abbey Street. The shop stood opposite Abbey Gate. To its right, and in Newdigate Street, was Halfords. The chemist ceased trading here on 15 June 1963, and Reg took the photograph on 23 June. The business was taken over by Iliffe's in the Market Place.

The painted advertisement on the wall was redolent of much earlier days, the no waiting sign in front of it a portent of further restrictions to come. *(1311)*

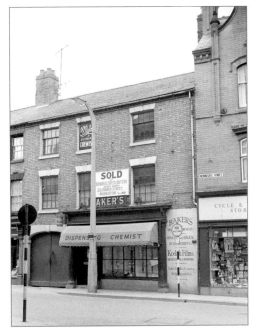

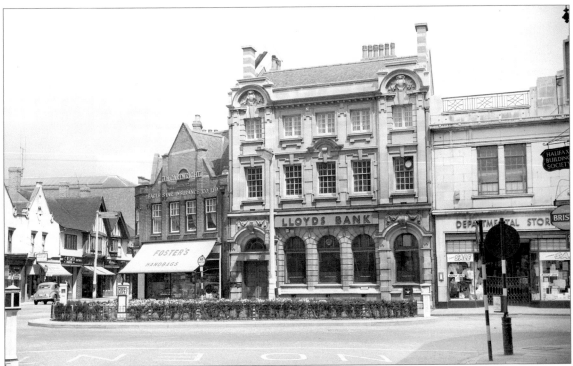

This is still one of those pictures that surprises. It was taken in June 1963, but every building in immediate view still remains in 2016. The fine 1900s Lloyds Bank is now Hawkins estate agents, and J.C. Smith is now Debenhams (it was then, but they had kept the old name). In the foreground now stands the John Letts statue of George Eliot. Further down Newdigate Street there have been major changes since 1963, but you can take this page to Newdigate Square and pick out all the buildings! *(1310)*

The Wesleyan chapel on the corner of Abbey Street and Stratford Street, Sunday, 23 June 1963. It is awaiting demolition, as is D.S. Jones. The Wesleyan chapel had been rebuilt in the 1880s by Reginald Stanley. He also contributed to the Liberal Club on the other corner (now used on the ground floor by Barnardo's charity shop). The block of shops that replaced the church is particularly undistinguished. *(1313)*

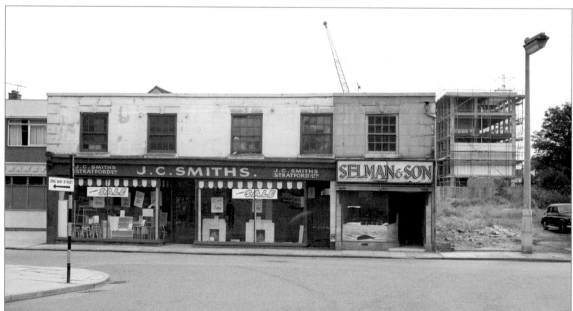

Kitchen cabinets for 79s 6d, tables for 85s and fireplaces for £7 19s 6d at J.C. Smith in Bridge Street, 23 June 1963. Smiths is surrounded by redevelopment. The newly built Granby (now Bilberries) shows the new building line and on the right the new police station is being constructed. Wilkinsons and the post office now occupy the site. *(1315)*

The number of small family butchers has declined rapidly in recent years. Fletcher's was one of them in the Market Place. On the rebuilt site now a mobile phone shop. Next door Boots optician department occupies the site of the old Maypole. All those small grocers, often chains like Maypole, have disappeared. They were taken over, closed down and lost to the march of the supermarkets. But many of us will recall Sunday teas with items prominently advertised in the window here – raspberry jam and tinned fruit with tinned cream. The picture was taken on Thursday, 4 July 1963. *(1336)*

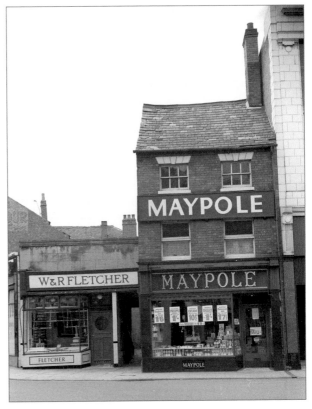

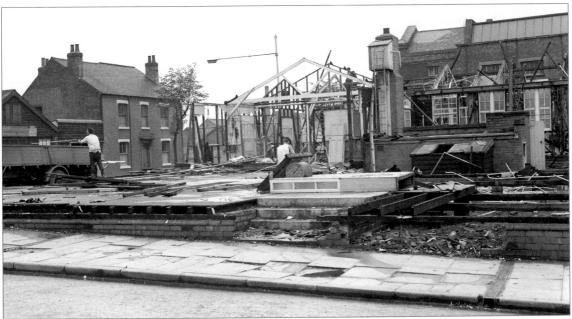

The corner of Regent Street and Leicester Road, 30 June 1963. The men are demolishing the old Employment Exchange, which had moved to Vicarage Street. On the right the building behind the demolition site became the Millennium nightclub, and is now a fitness centre. *(1317)*

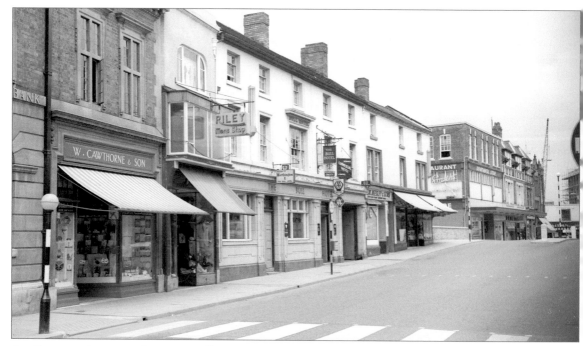

Another rare instance of a scene still recognisable fifty years later. Cawthorne's closed the branch here and moved in May 1970 to Corporation Street (see page 63). The shop is now part of the Santander. There were still shops known as gents' outfitters in the 1960s. Two of them are shown in this picture, but very few remain now. The Bull became the George Eliot. The picture was taken on Thursday, 4 July 1963. *(1337)*

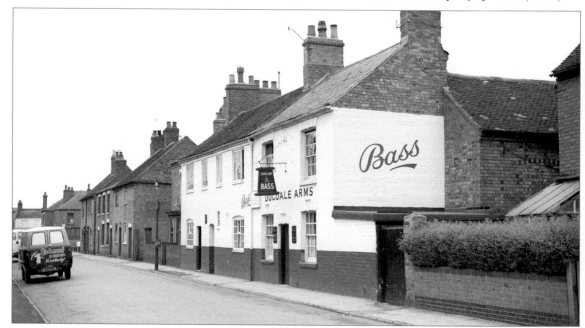

Another picture taken on 4 July 1963 shows a view of Dugdale Street (see page 34), but this one looks towards Queens Road. Within a year all the buildings in the picture had disappeared. The Dugdale Arms was replaced by the Merevale. The van on the left advertises Richmond sausages. *(1344)*

Both pictures on this page were taken in Abbey Street on 4 July 1963. The Scala (right) is still there as a shell, but in 1963 it was still a cinema. Breen's was another gents' outfitter with window displays by the cinema foyer. They also specialised in industrial clothing. The buildings to the left of Burgage Place have since been redeveloped.

The picture below is only a hundred yards further up Abbey Street. Reg Bull was standing outside the Ritz cinema when he took it. All the buildings shown have gone to make way for a car park. Many will remember advertisements on television for 'Davenports beer at home', and many will recall Picken's cafe from their youthful days. Remember the numerous shops like Bates the confectioner and tobacconist with the Cadbury's chocolate slot machine outside? *(right: 1347; bottom: 1348)*

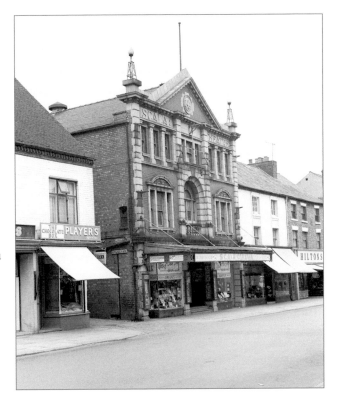

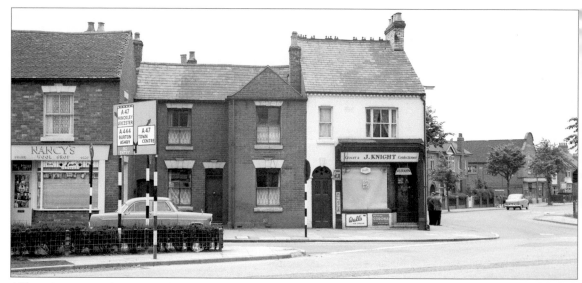

Abbey Green, 4 July 1963. Abbey Green has seen many changes in forty years, though many of the old buildings remain. Traffic has been the undoing of the area. A closer look at Knight's shopfront brings back memories. The cigarette advertisements for Craven A and Bristol, the Corona fizzy drinks (with their distinctive stoppers in the days when you returned bottles and got the deposit back) and the slot machine for chewing gum fit their times, as does the blind lowered when the shop was closed and the metal gate across the doorway. *(1349)*

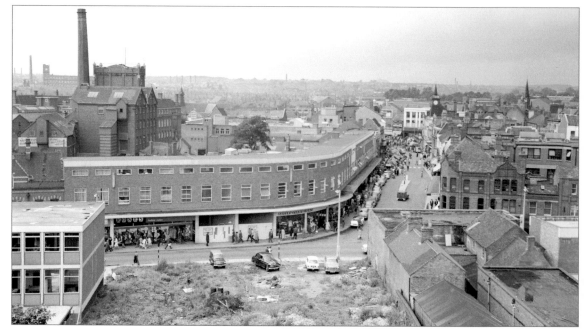

Part of Church Street and Bridge Street from the top of the new police station, Saturday, 10 August 1963. The new line of shops had only recently been completed and two units are still to let. Roses fashion centre and the Eastern Carpet Stores have already opened for business. Behind the new block can be seen the flour mill, which dwarfed most of the surrounding buildings. The open space in the foreground became the Post Office, but that too has moved to a smaller premises in Abbeygate Shopping Arcade.*(1435)*

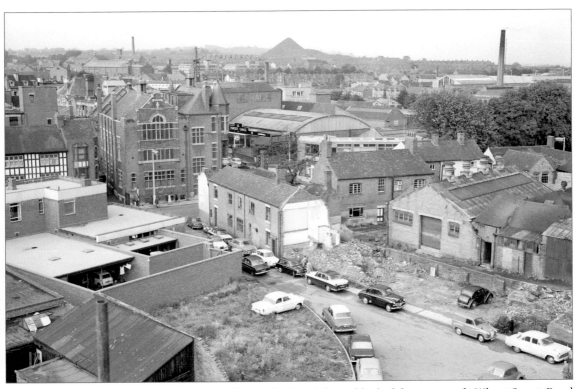

Still on top of the new police station, Reg Bull turned to his right and looked down towards Wheat Street, Bond Gate and Newdigate Street. The Conservative Club, a very fine building, is still there, but practically everything else has gone. The complex of buildings on the right included the Observer Works, which is now the Fedex headquarters. Beyond them and into Newdigate Street was the Parkside Garage and Parsons, Sherwin & Co. Ltd. The new buildings there were used by Triton Showers among others. In 2016 it is a Wetherspoon's pub. The chimney to the right was Biddle's in Newtown Road, now part of the Asda site. *(1437)*

Reg Bull next turned to view what was happening behind the new police station on 10 August 1963. The picture shows Vicarage Street School, built in 1848. It was one of four provided through the energy and dedication of the Revd Robert Savage, vicar of Nuneaton from 1845 until 1871. The school moved to Windermere Avenue and changed its name to St Nicolas. *(1438)*

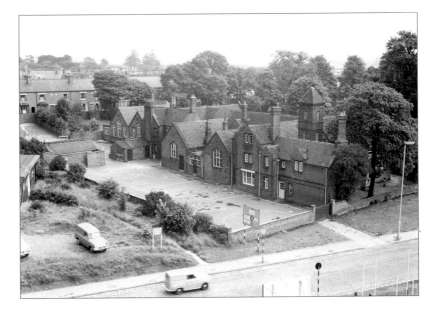

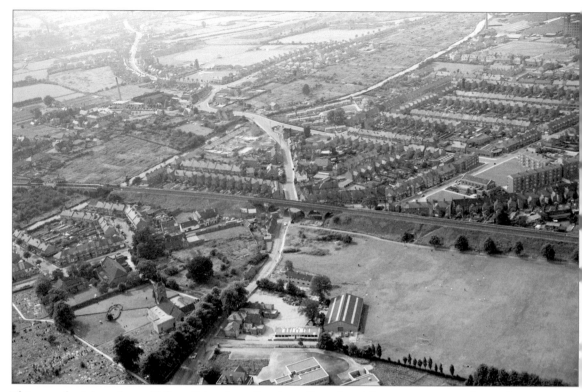

This superb picture shows Chilver Coton from the air on Saturday, 17 August 1963. It shows the impact the railway had on the landscape, matched only by the impact the new road was to have a few years later (see pages 83–7). Avenue Road is bottom centre, with the school and church. Most property within 100 metres or so of the arches was later (1973) demolished, including the whole of one street, Arthur Street, to make way for the new A444 from College Street. *(1454)*

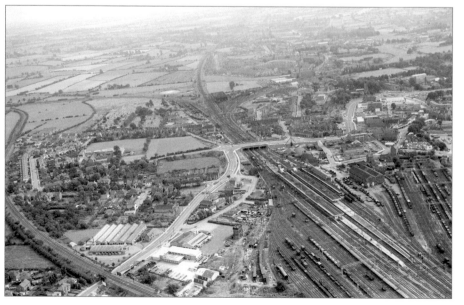

The railway station and Weddington Road in August 1963. All the sidings have gone, mostly to make way for the Asda site. The large factory, bottom left, in the corner of the railway and Weddington Road, was Finn's shoe factory. Wickes DIY occupies the site today. *(1455)*

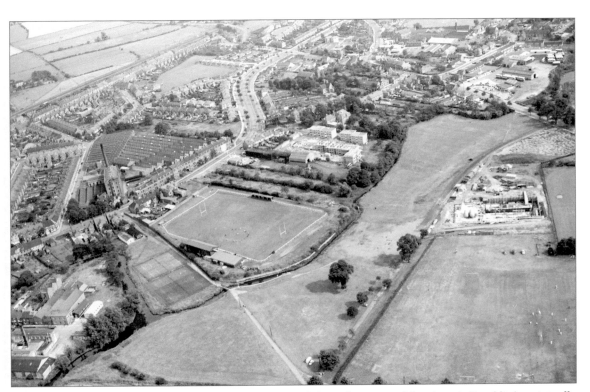

Attleborough and The Pingles, 17 August 1963. Bottom left, in the curve of the river, is Franklin's, originally Slingsby's specialist ribbon weavers. Lister's factory is surrounded by artisan housing dating from the turn of the twentieth century. There appears to be some pre-season training going on at the rugby ground, and work is under way on the Simon Close flats and houses. To the right the Pingles swimming pool is under construction. Its replacement was completed in 2003. In the top right corner of the picture is Lloyd's bus depot. (1456)

The town centre, August 1963. The road from left to right across the bottom of the picture is Dugdale Street. Bottom left shows the mostly cleared gas works being used for car parking. Centre right shows the new road and roundabouts linking Coton Road and Church Street. (1457)

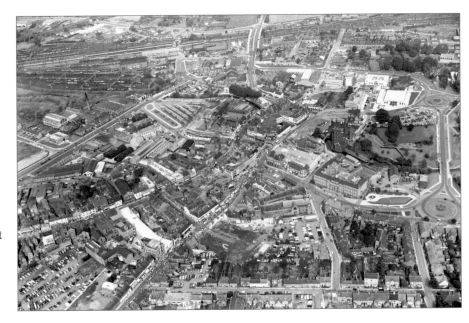

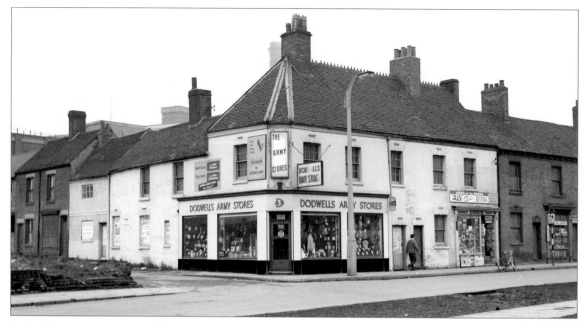

Dodwell's Army Stores in Abbey Street, Sunday, 26 January 1964. Almost the whole of Upper Abbey Street, from High Street to Abbey Green, has changed beyond recognition. A handful of original buildings remain at either end of the street. The pictures on this page and page 45 show a selection between High Street and Meadow Street. *(1590)*

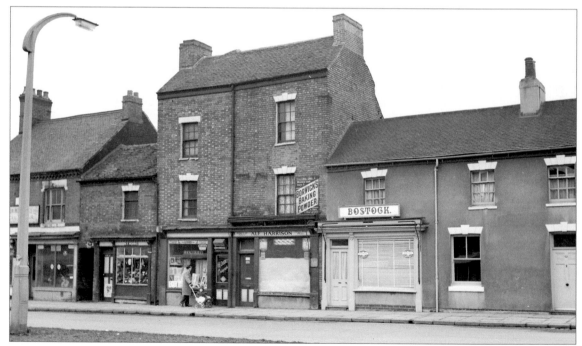

An interesting mixture of buildings, mostly early or mid-nineteenth century, and all to disappear over the five years after this picture was taken. Horace Dudley's shop moved to Queens Road in 1969. Bostock the butcher also relocated to the centre of town. *(1591)*

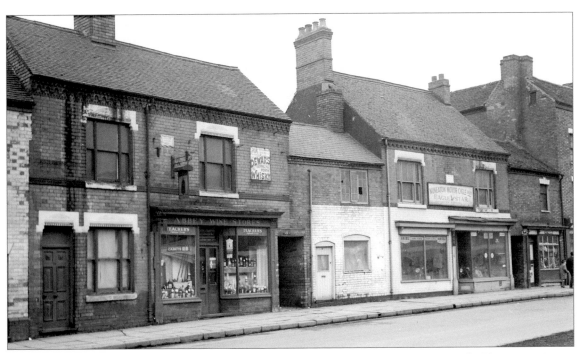

Moving down Abbey Street towards High Street we see the Nuneaton Motor Cycle Co. and Abbey Wine Stores. The passage was to one of the many courts of tiny, enclosed, overcrowded tenements that once stretched the length of Abbey Street. Moving to his left again Reg Bull photographed Mr Moore's pot shop (below), set out in converted front rooms, as so many tiny shops were. *(top: 1593; bottom: 1592)*

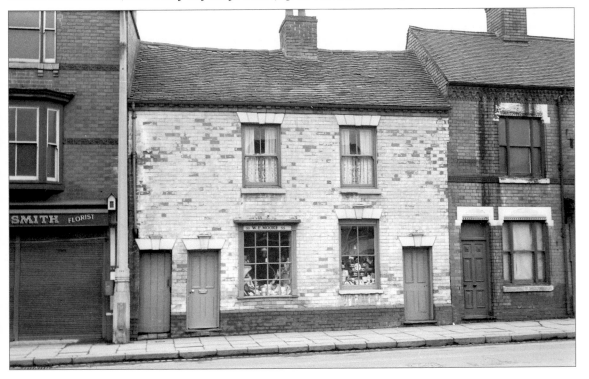

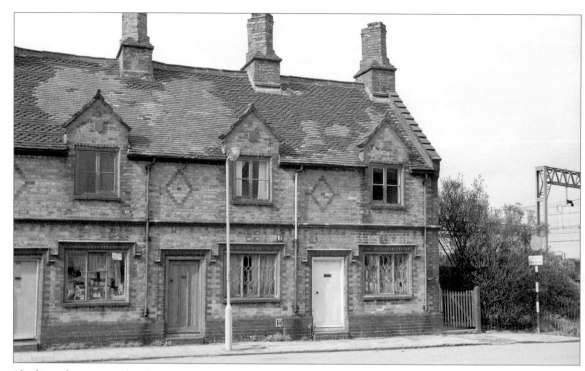

The line of cottages, often known locally as Apostles Row, was about to be demolished when Reg Bull took this photograph on Sunday, 26 April 1964. The cottages stood at the top of Wheat Street, and the railway can be seen running across the top of the street. *(1672)*

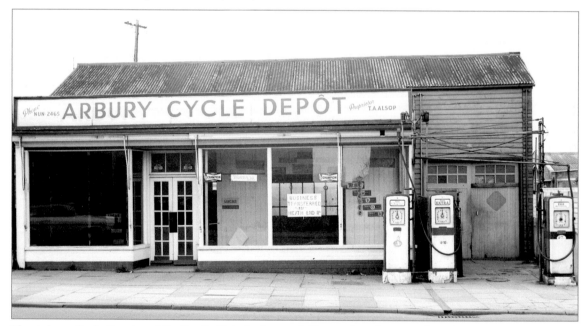

The Arbury Cycle Depot and the Studio Hair Styling and Chiropody Salon next door, but off the picture, were both about to be demolished when Reg Bull took this picture on Wednesday, 29 April 1964. Petrol then was 4s 10d a gallon. A petrol station was built on the site in Arbury Road. *(1683)*

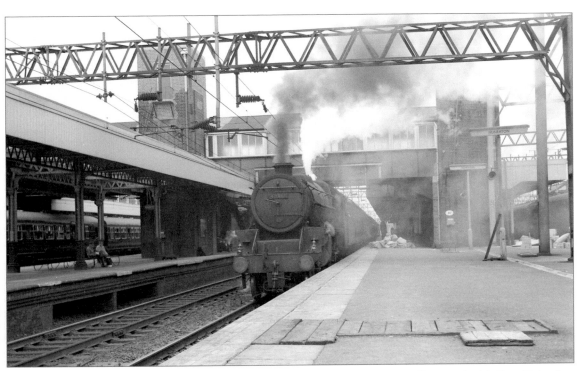

Electrification comes to Nuneaton. This steam train, no. 45101, was en route to Euston. At this time (Saturday, 13 June 1964) electrification stopped at Nuneaton and steam and diesel took the trains on to Euston. *(1792)*

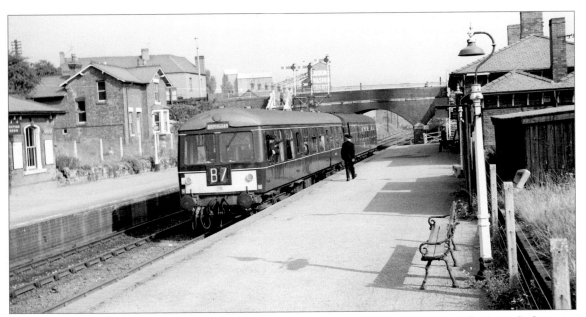

At this time there was still a station at Abbey Street. In the background can be seen Judkin's washed granite processor, which was adjacent to the quarry on Tuttle Hill. The 12.21 Leicester to Birmingham train is about to depart on Sunday, 4 October 1964. The 1960s also witnessed the Beeching axe, when hundreds of small, rural stations and lines were closed. *(1934)*

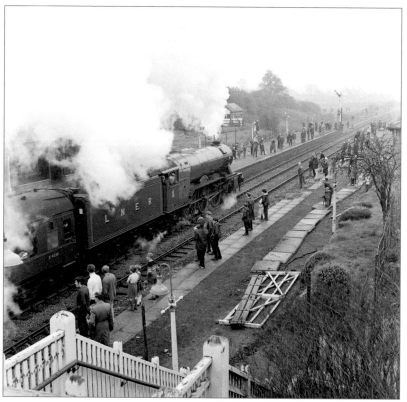

This was a special occasion, on Sunday, 4 May 1969, when no. 4472 *The Flying Scotsman* passed through Abbey Street station with a special excursion to Tyseley. According to Reg Bull, a stickler for these things, it was twenty minutes late. By 2016 a delay of only twenty minutes would pass unremarked! *(3375)*

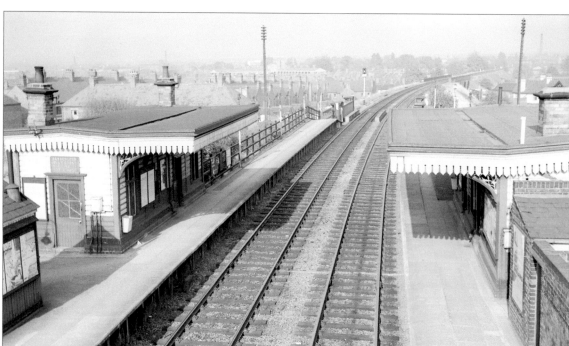

Chilvers Coton Station, looking towards Coton Arches from College Street, 4 October 1964. *(1937)*

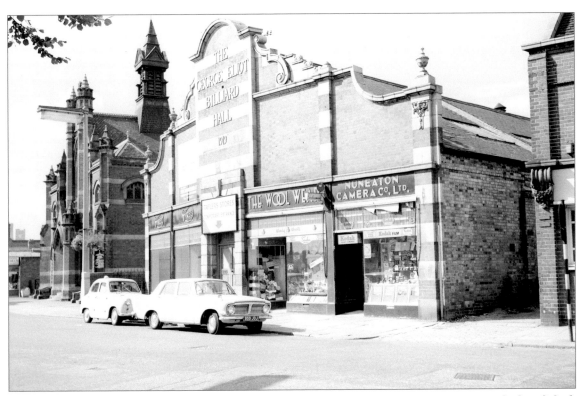

The George Eliot Billiard Hall, built in her centenary year, 1919, was later to be unceremoniously demolished. It had a rather splendid frontage, but its replacement (see page 92) is also a pleasing design. Billiard and snooker halls were not very fashionable in 1964, although they were to enjoy a huge growth in popularity with the coming of colour television. The Doree shop is to let and the billiard hall doorway is providing a temporary entrance to the Tatler store in the Market Place. The camera shop was to close a few days after the picture was taken on 20 September 1964. *(1921)*

Old and new in Queens Road, Sunday, 4 July 1965. On the left is the new block, which includes Queens Arcade (in turn to be demolished for the Rope Walk development in 2004). Awaiting demolition is Jack Warren's sweet shop and the George and Dragon pub, with its bricked-in top-floor windows revealing an earlier use by ribbon weavers. Present-day economics mean that little clothes shops like P & D Stores can no longer make a living. *(2094)*

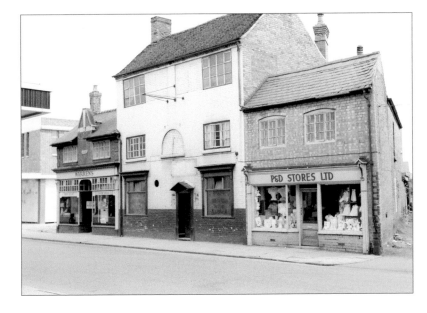

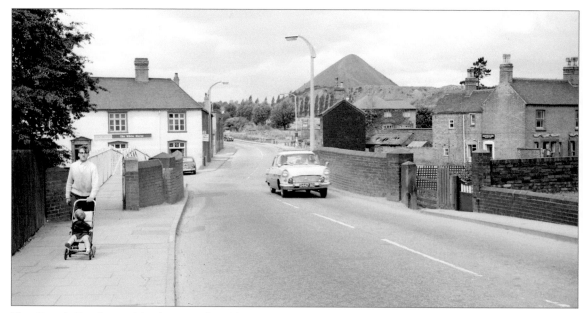

The Punch Bowl canal bridge, Tuttle Hill, Sunday, 1 August 1965. To the left of where Reg Bull was standing when he took the photograph is the bridge over the railway served by Abbey Street station (see page 47). Behind the White Horse pub is the old Nuneaton Engineering factory, run by Reginald Stanley a century ago. The buildings are still there in 2016 but not for long. *(2102)*

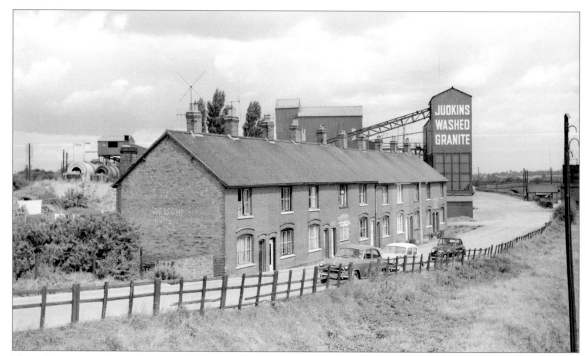

These houses in Stoney Road are still there, as are the notices painted on two walls saying 'Welcome Home George'. There were two Georges: George Clamp and George Evans. George Clamp was parachuted in 1944 to help secure the Pegasus Bridge. He died in 1990. George Evans was in the 8th Army and saw action in North Africa, Sicily and Italy.*(2103)*

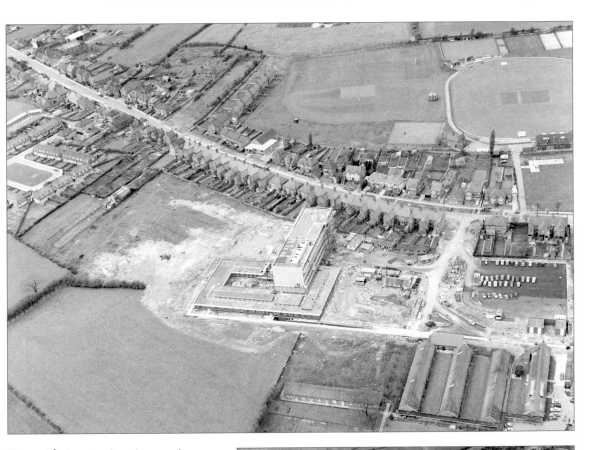

George Eliot maternity wing nearing completion, Wednesday, 27 April 1966. Heath End Road goes across the top of the picture, with Griff and Coton sports field on the top right. Below are the original emergency hospital wards. A similar aerial view taken today would reveal huge changes. *(2197)*

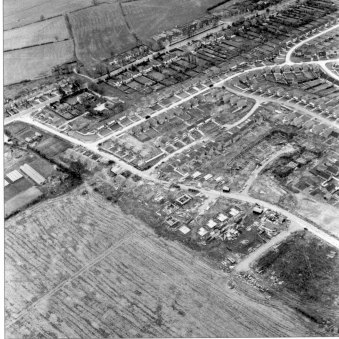

This fascinating picture from April 1966 shows the expansion of housing that was to be a feature of the next thirty years. It shows Hinckley Road at the top, mostly inter-war ribbon development. Running across the middle of the picture is the new St Nicolas Park Drive with houses under construction, while most of those in Windermere Avenue had been finished. *(2221)*

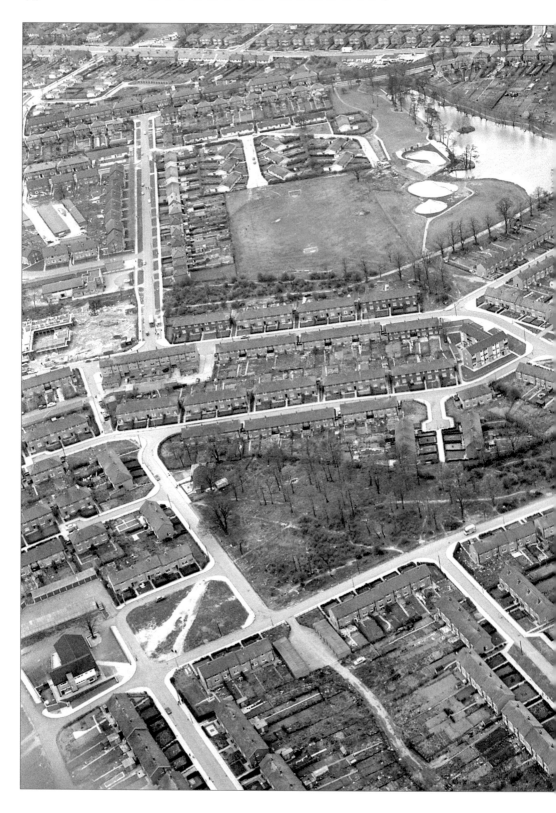

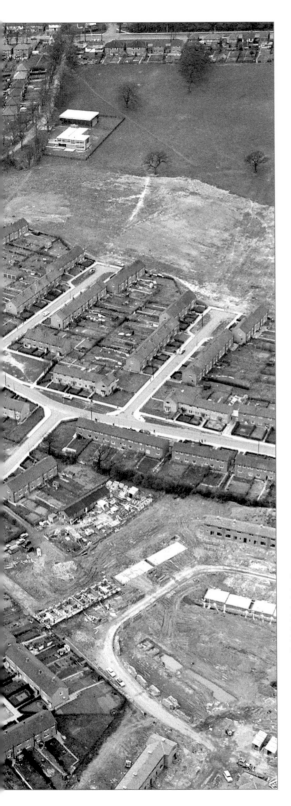

This superb photograph shows a rare view of the Camp Hill estate. Most of it had been completed during the previous decade, but on the edges building is still taking place. The bottom right of the picture shows what is now Laburnum Grove. Top centre is Stubbs Pool. Top left, going up the picture, is Ramsden Avenue, and building is taking place on the corner of Cedar Road, opposite the shops, where the Pride in Camp Hill office now is. Lower left is the pub (demolished 2003) with Hillcrest Road coming down to the bottom of the picture. Parts of Cedar Road, top right, are to be redeveloped as part of the Camp Hill regeneration scheme. Interestingly, in this picture, taken on 27 April 1966, only a handful of cars is visible. *(2232)*

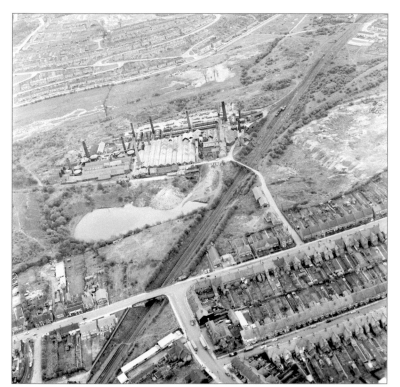

Two examples from the air of industries that once employed thousands. Reg Bull took these on 27 April 1966. Left is the Haunchwood Brick & Tile Co. Ltd. The factory has gone though the lake remains, and the open space is now Whittleford Park, with the boundary at the top being Queen Elizabeth Road. Haunchwood Road goes across the bottom of the picture. The view below shows Stanley's brickyards on Croft Road, which goes diagonally across the picture. The entire site is now covered by housing, largely the Sunnyside estate. *(left: 2235; bottom: 2236)*

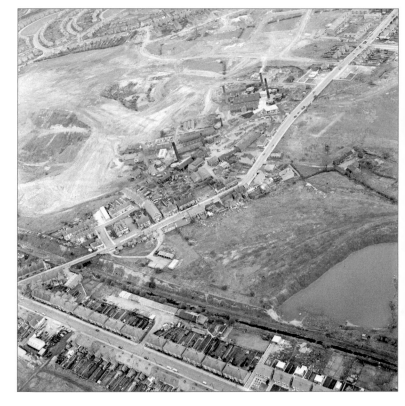

Ranby's was a well-known chemist and wine merchant on the corner of High Street and Abbey Street. It was demolished in the 1970s to make way for Roanne Ringway. Strip away the advertising hoardings and there was a fine town house. Reg Bull was standing outside the Ritz cinema when he took this picture on Sunday, 10 July 1966. *(2251)*

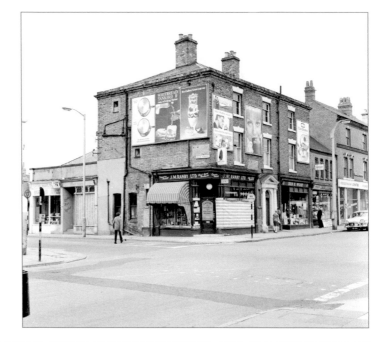

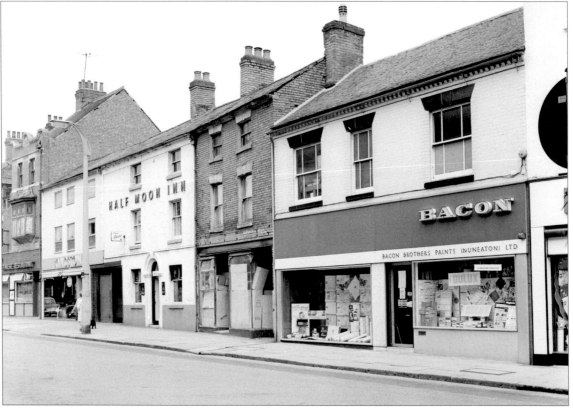

Most of the buildings are still here in this part of Abbey Street, though some have been rebuilt and the Half Moon is no longer a pub. *(2253)*

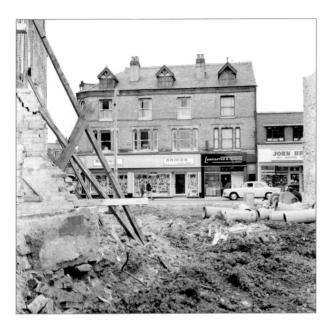

Reg Bull took this picture in Abbey Street in July 1966 after the old Halford building had been demolished. The building occupied by Briggs is now Greenwoods. *(2257)*

The Newdigate Arms Hotel being demolished on Sunday, 7 August 1966. The picture was taken in Newdigate Street. The demolition left the town without a hotel. Had it clung on for another decade, the motorways and the NEC would have ensured its prosperity. As it was, Nuneaton was blessed with the Heron Way development, now Abbeygate. *(2278)*

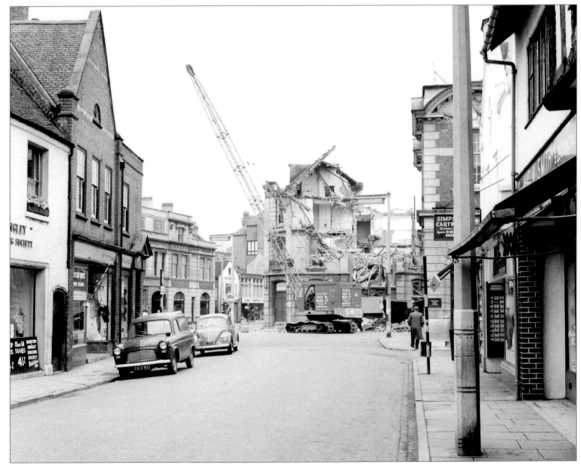

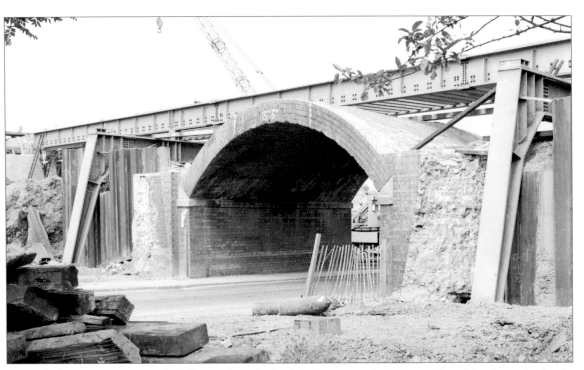

As roads became more crowded the bottlenecks had to be removed. This was the old railway bridge in Weddington Road and the picture, taken on Sunday, 28 August 1966, shows part of the old bridge and behind it the new one in the course of construction. The picture was taken from the grounds of Finn's shoe factory. *(2289)*

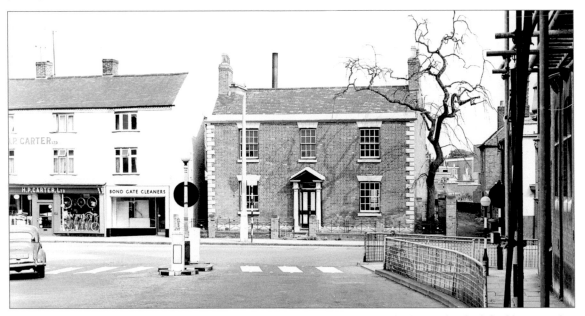

The old Georgian-style manse in Bond Gate, not far from the Zion chapel it had served, which had been used in recent years by the *Nuneaton Observer*, itself due to close two years later. A tall office block now stands on the site but in 2016 it is empty.

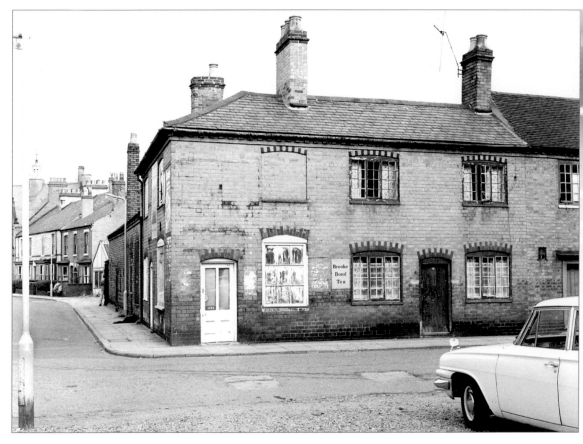

An empty little shop on the corner
of Dugdale Street and Chapel Street,
Sunday, 28 August 1966. In the
distance on the left can be seen
the rooftop feature on what is now
the Yorkshire Bank. Every other
building in the picture has gone
and the whole site is now a car park
– for a while. *(2303)*

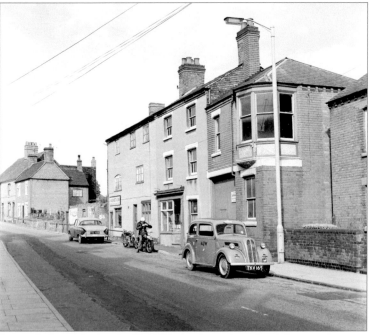

Some of the old buildings, including
Bennett's motorcycle shop in Bridge
Street, Chilvers Coton, in August
1966. This part of the town was to
be decimated by the new road a few
years later. *(2371)*

Another example of a photograph that Reg Bull executed so well. It simply records the little fish-and-chip shop in Bridge Street, Chilvers Coton, on Saturday, 10 September 1966. The building to the right is the Conservative Club. *(2373)*

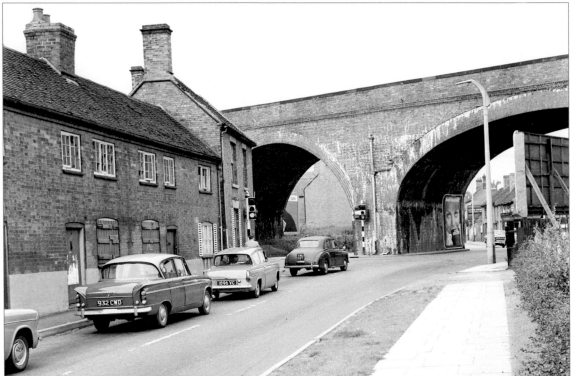

Avenue Road, Chilvers Coton, Saturday, 17 September 1966. Some of the cottages on the left are already boarded up and awaiting demolition. The site is now mostly on the roundabout, but there has been a new development of an old people's complex on the redrawn corner with Coventry Road. *(2407)*

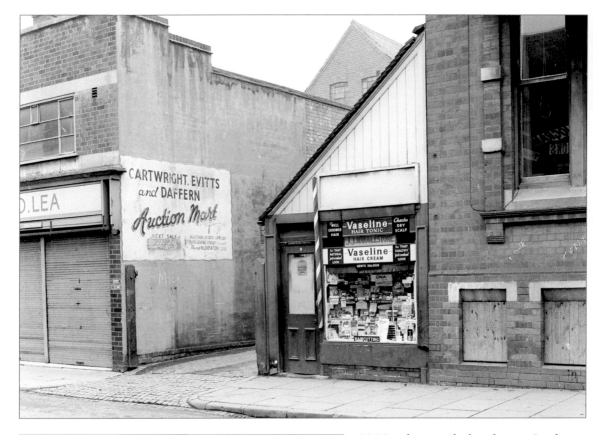

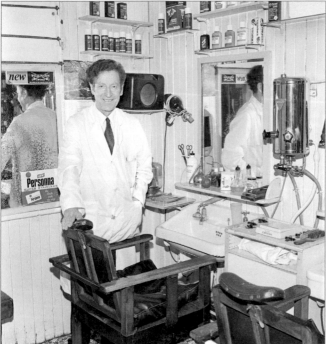

J.J. Mugglestone, the hairdresser, Sunday, 6 November 1966. This little shop was at the side of the Liberal Club in Abbey Street. Down the side passage is a sign to Cartwright, Evitts and Daffern's Auction Mart, which was presumably held in the old factory building revealed when part of Queens Road was demolished in the late 1990s. The picture on the left was taken on Wednesday, 13 November 1974. John Mugglestone, originally from Leicester, lived in Windmill Road. He started his business in 1946 and it eventually closed on 27 September 1975.
(top: 2487: bottom: 4913)

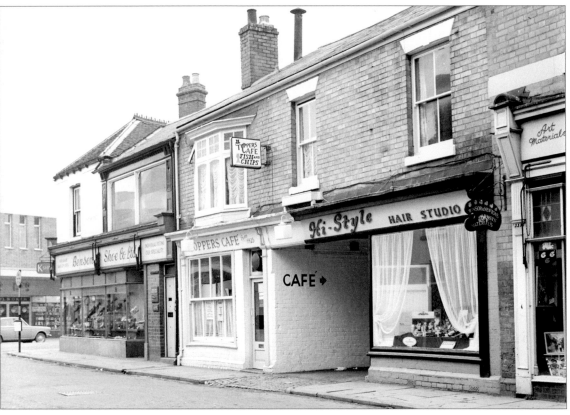

Stratford Street near its junction with Queens Road on Sunday, 6 November 1966. The new Woolworths can be seen on the edge of the picture. Toppers has prospered and expanded and is still here. Benson's took over the shoe shop from Moreton's in 1945. They were here until 1981 (see page 104). *(2489)*

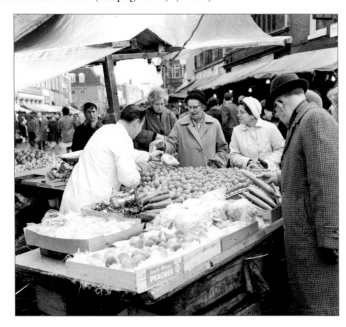

Operating in the same spot on Saturday for many years was Clarke's fruit and vegetable stall, shown here on New Year's Eve 1966. *(2543)*

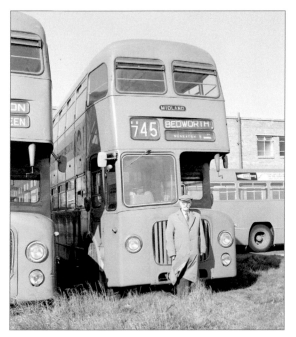

Seeking out photo opportunities like this appealed to Reg Bull. It shows Mr F.J. Scarr, aged eighty-one, of Hartshill, who drove the first petrol electric bus in Nuneaton during the First World War era. He is standing in front of a modern bus at the Midland Red garage in Newtown Road on Sunday, 19 March 1967. Bedworth residents will note with pleasure that Bedworth is written in bigger letters than Nuneaton on front of the bus. *(2619)*

The demolition of the Methodist chapel on the corner of Edward Street and Queens Road on Friday, 10 March 1967. The church was no great architectural gem and looks rather heavy-handed in design, but the design for the replacement block of shops is dire. *(2614)*

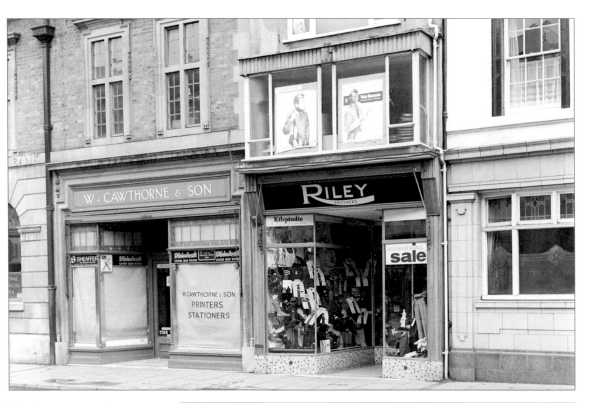

Riley's menswear shop was soon to close and move to Queens Road when this picture was taken on Sunday, 2 April 1967. Cawthorne's was next to the National Provincial Bank and the picture on the right shows Mr William Cawthorne inside the shop on Saturday, 13 December 1969. Cawthorne's moved the following year.
(top: 2626; right: 3588)

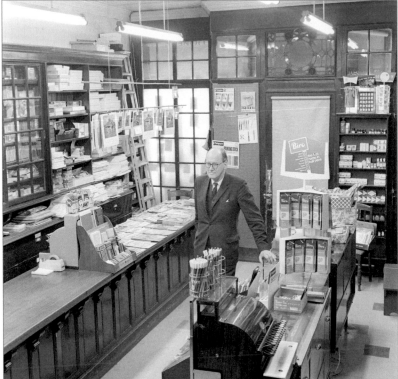

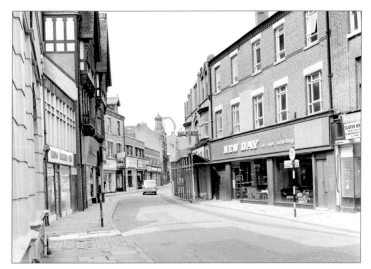

Newdigate Street on Sunday, 21 May 1967. All the buildings on the right were demolished to make way for Heron Way, now Abbeygate. Halfords was about to move a few yards up the road. New Day was another of the many town-centre furniture stores, most of which have disappeared. *(2677)*

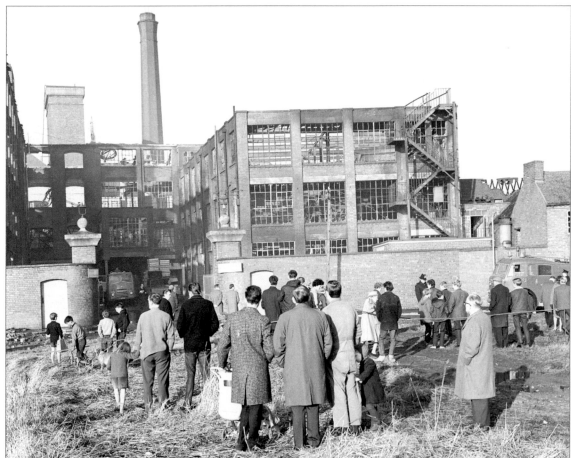

The Awson Carriage Works photographed the morning after it had been destroyed by a ferocious fire, Saturday, 16 December 1967. The factory between Meadow Street and Bottrill Street was originally the Hall and Phillips hat factory. In recent years it has been demolished and houses built on the site. *(2790)*

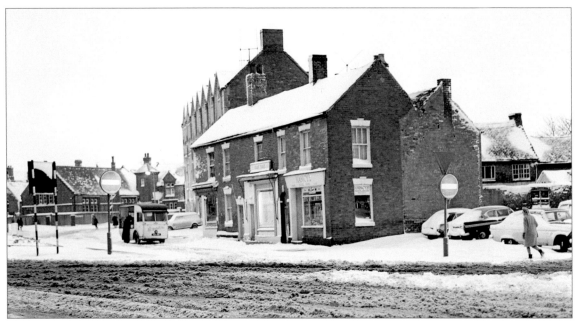

It is 8.15 a.m. on Tuesday, 9 January 1968. The three shops are still here, with Frank Parker's butcher's shop now using two of the units in this part of Abbey Green. The factory behind the row has now gone, as has part of Abbey Infant School, one of the church schools founded by the Revd Robert Savage in 1847. *(2811)*

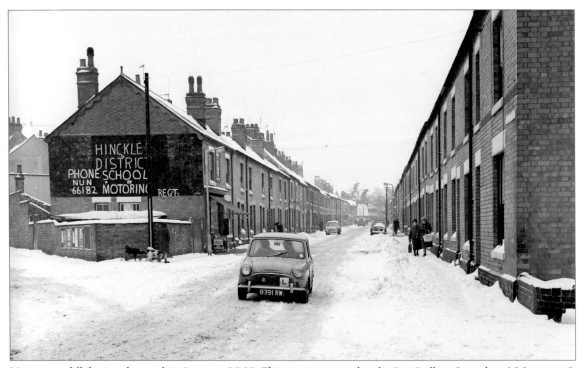

More snow fell during the week in January 1968. This picture was taken by Reg Bull on Saturday, 13 January. It shows Duke Street, looking up towards Manor Court Road. Few residents had cars and one wonders whether the Hinckley and District School of Motoring had planning permission for its advertisement. *(2822)*

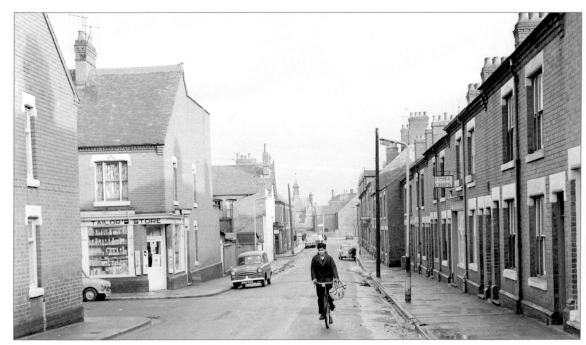

Another of the many pictures Reg Bull took of the streets close to where he lived. This one shows Windsor Street looking towards Dugdale Street and Chapel Street after the snow had gone in January 1968. The absence of cars and the presence of little shops is noticeable. Tailor's, on the corner of Alexandra Street, has no fewer than three slot machines for out-of-hours chewing gum enthusiasts. *(2828)*

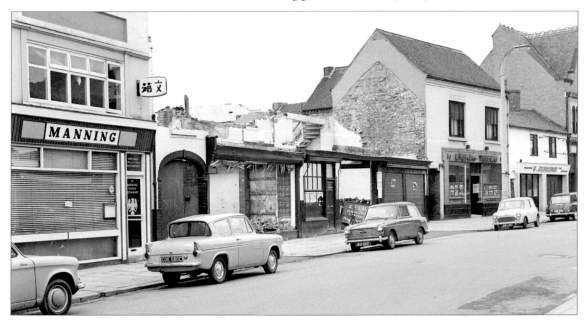

Abbey Street on Sunday, 11 February 1968. Being demolished is Hartshorn's (previously Jack Lenton's) fruit and vegetable warehouse. The other buildings in the picture were demolished soon afterwards and the Century Way car park is on the site now. To the left of Manning's Chinese restaurant was the Bull's Head, which is still there, though it has had several changes of name. *(2878)*

Part of the *Nuneaton Observer* printing works. It was housed in what had been a Zion chapel dating back to 1816. The paper closed on Wednesday, 29 May 1969, when it merged with the *Evening Tribune*, causing thirty redundancies. *(2972)*

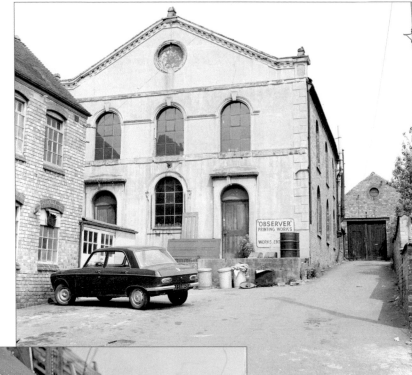

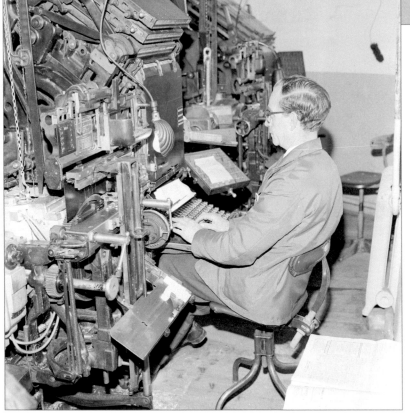

Mr L. Smith operating a linotype machine. Computer technology has transformed the production of newspapers. It is only forty-five years ago, but this machine would not be recognised by today's journalists and printworkers. *(2948)*

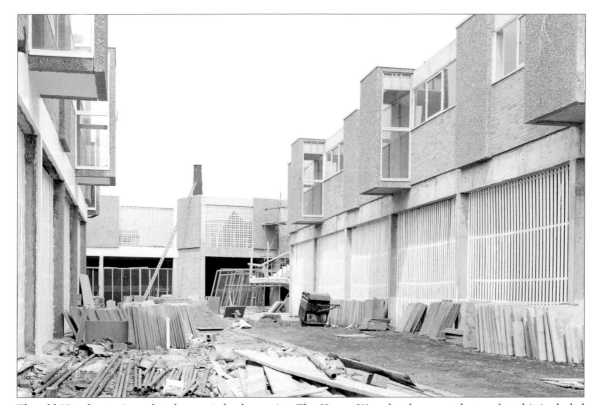

The old Newdigate Arms hotel occupied a large site. The Heron Way development that replaced it included shops and offices, and the open precinct shown above. Reg Bull took this picture of the redevelopment (which has since been upgraded and covered) on Sunday, 2 June 1968. *(2965)*

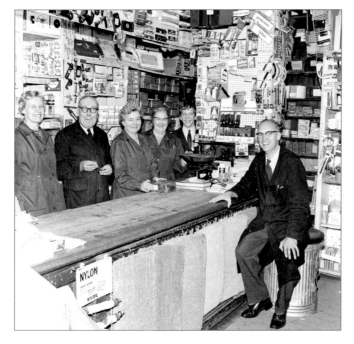

Inside R.A. Collett's ironmonger's shop in Queens Road on Friday, 30 August 1968. They all appear to be happy in their work. From left to right: Miss B.A. Dawkins (Mrs Collett's sister), Mr Ronnie Collett, Mrs Collett, Mrs Justin, Mr Ian Whitmore and Mr G. Randall. There are very few of these wonderful little hardware shops left. Most towns have lost them owing to the popularity of large DIY superstores. *(3090)*

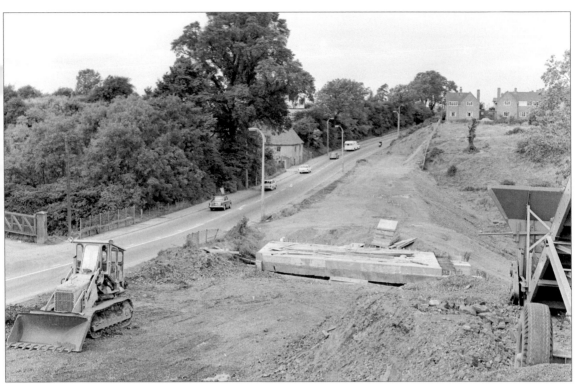

Work in progress on the road widening and new bridge at Griff Hollows, looking towards Hill Top and Nuneaton, Sunday, 22 September 1968. *(3166)*

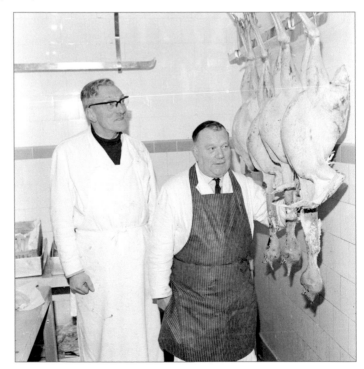

Bill Lea, the proprietor of J.O. Lea's poultry and fishmonger's shop in Abbey Street, with George Jarman, who had worked there for thirty-five years. Some of the Christmas turkeys are on display here on Tuesday, 17 December 1968. *(3219)*

Stanley Firmstone in his shop
in Abbey Street (near Meadow
Street). He and his wife Alma
bought the shop from Ernest Grubb
in 1954. He claimed to have had
about seventy break-ins in fifteen
years. The shop closed for business
on 17 March 1969.
(3293)

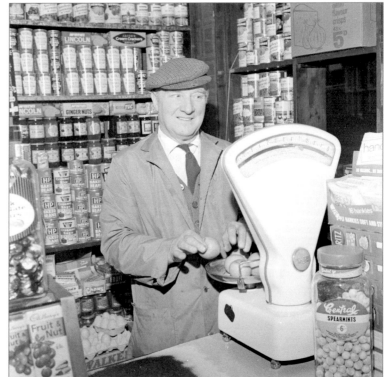

George Noon using the scales
behind the counter of the grocery
shop he ran at
84 Edward Street (on the corner
of Windsor Street), Wednesday,
12 March 1969. *(3297)*

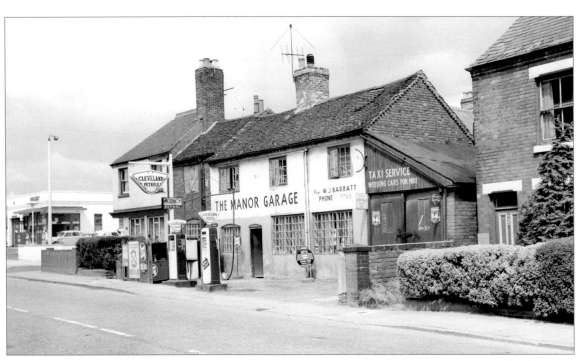

Barratt's Manor Garage in Midland Road, near Jodrell Street, Sunday, 1 August 1965. Barratt's also ran a taxi service. The old and new are well illustrated in this photograph. The Manor Garage clearly had an earlier use as a ribbon weaver's house, with its large windows to give light for the looms. As a garage it caused cars to obstruct the highway while they filled up with petrol. In the distance is a new purpose-built petrol station, complete with self-service and a forecourt. *(2104)*

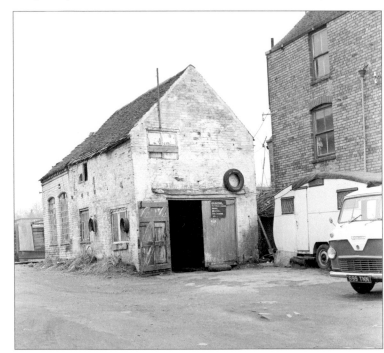

Tubby's Taxi headquarters in Abbey Street on Saturday, 22 March 1969. Another example of a building being used for different purposes, this little converted factory was nearly opposite the Coach and Horses. *(3304)*

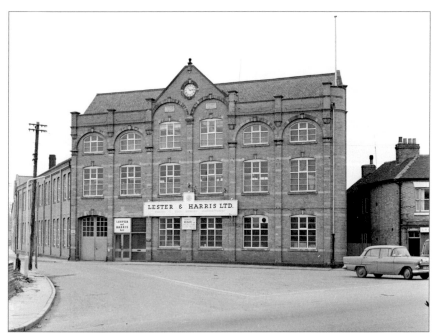

Change came to Attleborough, as it did to other parts of town, though the square has retained many original buildings. This was the Lester and Harris factory on Attleborough Green. Kem Street is on the left. Reg Bull took this picture on Sunday, 26 January 1969. Eventually it was demolished and the Co-op supermarket now occupies the site. *(3230)*

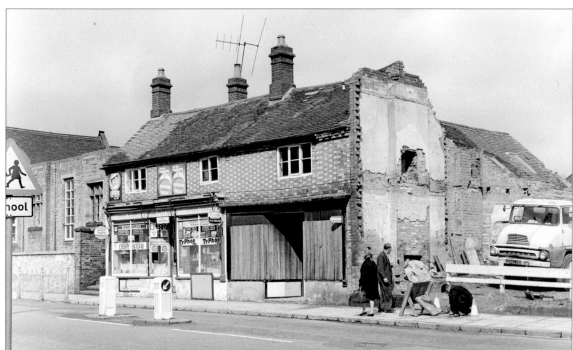

Shops in Attleborough Road next to what remained of Attleborough Church School, Tuesday, 15 April 1969. The school was one of the Revd Robert Savage's, dating from 1848. It was damaged during the Second World War. The roof of the shop run by P. & C. Potter suggests that it too suffered bomb damage. Both shops have gone and the space is now occupied by a car park. The school building remains, though not as a school. The shop was a typical general store with a range of groceries, sweets and tobacco. Judging by the advertisements in the windows, Attleborough people were particularly keen on cleaning their shoes. *(3352)*

Moving further into Attleborough in April 1969, Reg Bull photographed Harry Green's gents' hairdresser's shop in Bull Street. Hairdressers were still able to sell cigarettes to their customers and Woodbines, Consulate and Cadets are advertised in the shop. Further down Bull Street into Attleborough Square is the Royal Oak pub (below). All the buildings shown in this photograph are still there but are occupied by different businesses.
(right: 3356; bottom: 3357)

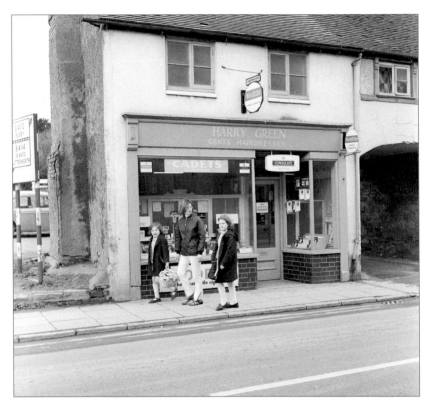

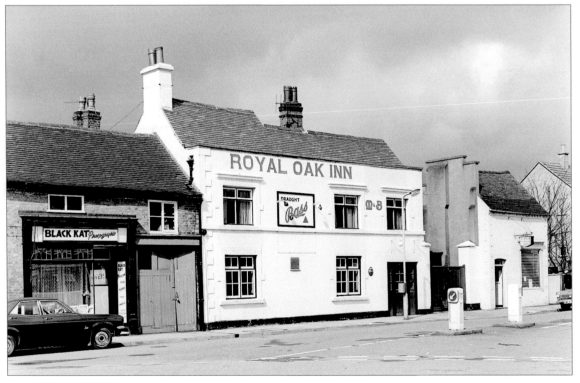

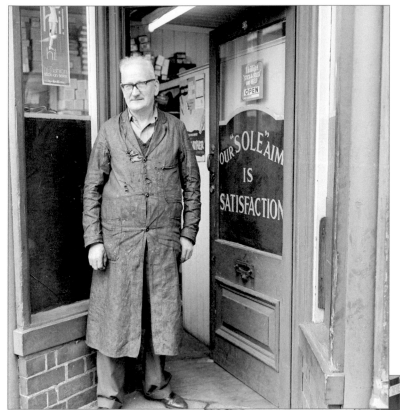

Alfred King, aged sixty-one, boot
and shoe repairer at his shop, 26
Windsor Street (on the corner
with Victoria Street), Tuesday,
22 April 1969.
Mr King had been in the trade
since he was thirteen, and had
bought his business in 1934
from the previous owner,
Mr Austen. When the building
was first built in about 1901 the
Midland Meat Company
had a butcher's shop there.
(3366)

Nancy Savage outside the shop in
Abbey Street near Meadow Street
(see page 44) on the last day of
business before it transferred to
Queens Road, Saturday, 26 April
1969. The shop had originally
belonged to Horace Dudley, who
had a chain of photographic studios
in the Midlands. *(3369)*

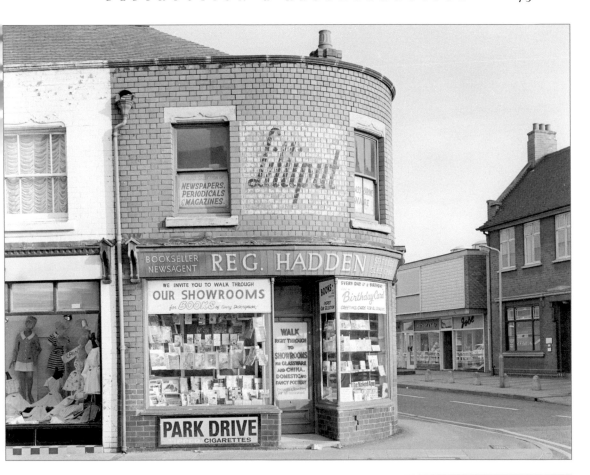

Reg Hadden's shop is still remembered fondly, as is the man himself. It stood on the corner of Queens Road and Dugdale Street, where the Iceland store is today. The curved first-floor brickwork was very distinctive. The picture was taken by Reg Bull on Thursday, 5 June 1969 and the shop was to close on Saturday, 28 June that year. *(3406)*

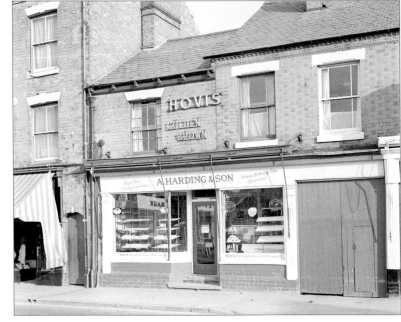

Also in Queens Road was Harding & Son's bakery. This picture was taken on 5 June 1969. *(3408)*

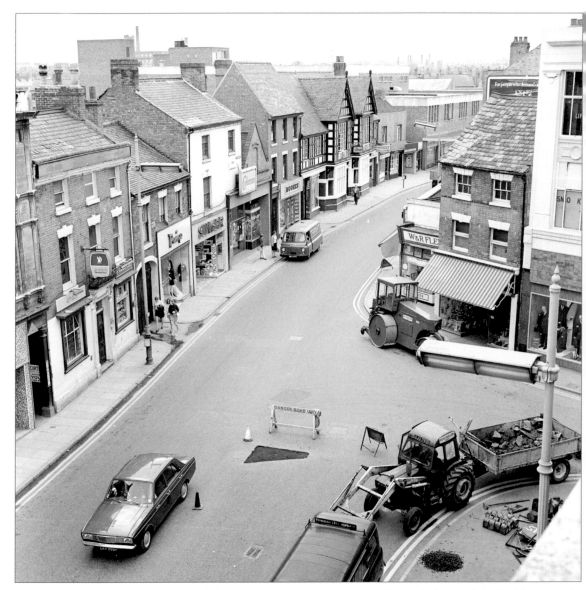

The superb photographs on this and the next page were taken from the roof of one of the buildings in the Market Place by Reg Bull on Thursday, 29 May 1969. Road repairs are under way, but few people are around. The shop owned by the Maypole (see page 37) in 1963 is now a shoe shop. The Red Lion and the Castle pubs are still there but not for much longer. Double yellow lines have appeared, and the girls are wearing 1960s mini-skirts. *(3383)*

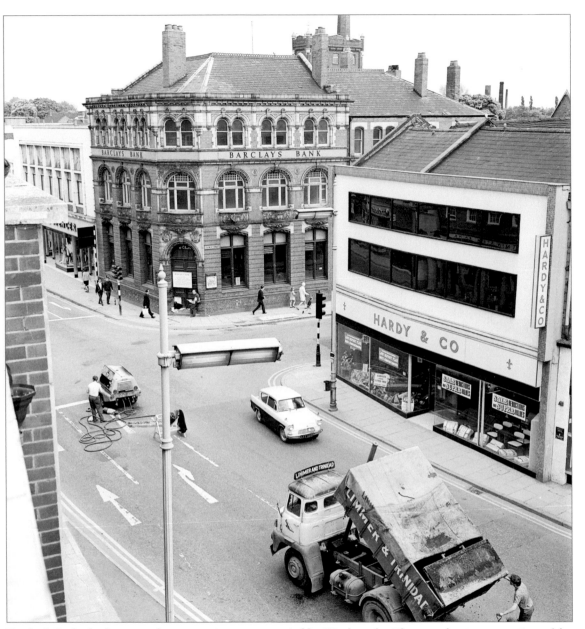

Hardy & Co. had taken over the corner site once occupied by Woolworths. They set about constructing a false front, which is pretty ghastly. Fortunately it did not last long. They are offering a low deposit plan and carpets costing 39s 11d a yard fitted free. Barclays Bank is still one of the best buildings in the town. Behind it the flour mill roof and chimney can just be seen. (3384)

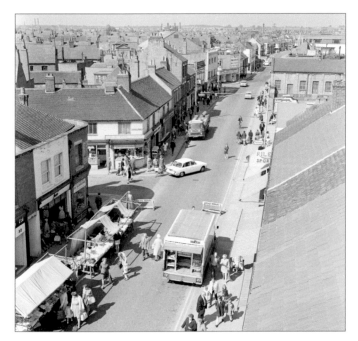

Queens Road from the top of the Co-op building, Saturday, 7 June 1969.
It seems familiar now though there have been many changes. There is no sign yet of the Roanne Ringway. Part of the gas works is still standing on the right, and the Palace cinema is still open.
(3409)

Abbey Street from the roof of the Co-op, Saturday, 7 June 1969. Most of the shops on the left have disappeared, and many of them are shown on earlier pages. On the right is the Ritz cinema. Powell's wallpaper shop and adjacent building were to be demolished to cut a road through from Abbey Street to Newtown Road. The new road, Powell Way, commemorates the shop. As we reach the end of the 1960s it is noticeable in many of the photographs how many more cars are on the streets. *(3419)*

Sweet shops and tobacconists as we remember them, with bottles of sweets which are weighed out in front of us and put into a paper bag to tempt us on the way home! Reg Bull's picture is of Jack and Dorothy Warren behind the counter of their sweet shop on the corner of Stratford Street and Queens Road on Wednesday, 23 July 1969.
The Warrens are still remembered. Jack was a county councillor and had run this business since 1948. *(3510)*

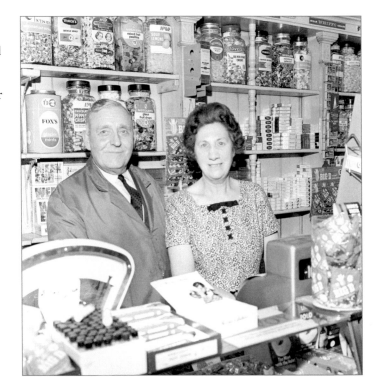

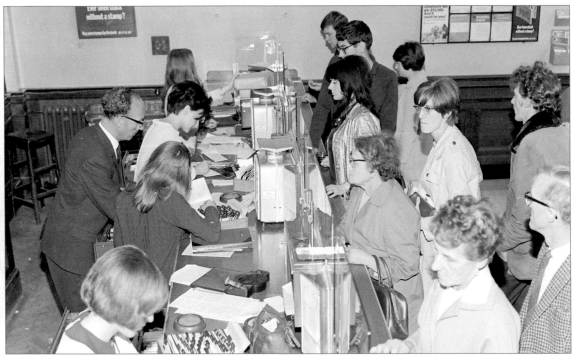

I am not sure how Reg got away with this picture, taken on 26 August 1969. He is standing on the counter of the old post office in the Market Place to take a picture of the staff serving customers. Imagine the reaction if someone tried to do it today! *(3522)*

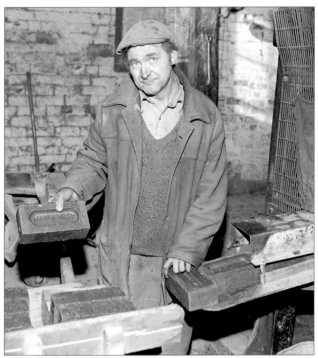

Another example of a trade no longer based in Nuneaton. The picture on the left shows Clifford Matthews taking newly cut bricks off the processing machine, prior to baking. The one below shows some of the workers outside the Ansley Hall Brickworks on Friday, 28 November 1969.
(left: 3574; bottom: 3582)

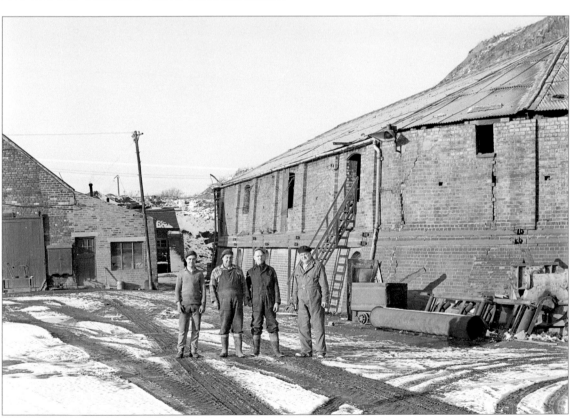

3 Make Way for the Car
– the 1970s & 1980s

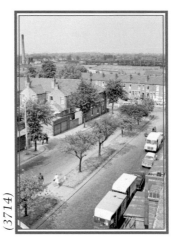

(3714)

I have grouped the 1970s and 1980s together because they essentially continued the process started in the 1960s of trying to accommodate the car in crowded town centres. Although Reg Bull was still taking photographs in the 1990s I have, with the odd exception, stopped the selection at 1990, to allow for a historical perspective.

The decade started with decimalisation of our currency. During the 1970s we saw Ted Heath's election victory, followed by Harold Wilson, his surprise resignation and succession by Jim Callaghan, the winter of discontent and the rise of Margaret Thatcher. It was a decade of rampant inflation and industrial unrest, which included power cuts and the three-day week. Thatcher's decade was in some senses a reaction to a perception that the unions were too powerful. Taming the unions and privatisation will be two things she is remembered for.

All these national trends were reflected in Nuneaton's life. Many more traditional industries closed. Job insecurity increased, as did unemployment. The global market place was hitting hard. Local government felt under attack in the 1980s, having undergone radical change in 1974. Thus, by the end of the 1970s Nuneaton included Bedworth in its title and the enlarged authority needed a new building in the 1980s for its expanded workforce. There were also radical changes in education with the introduction of first, middle and comprehensive schools to replace infant, junior and high or grammar schools, and after 1974 most of the town's education decisions were made in Warwick.

The town was further transformed to allow easier access for cars. A dual carriageway from the town centre to the M6, a completed inner ring road and town-centre pedestrianisation with extra car parks were but a few of the changes during these years. Supermarkets put paid to most family grocers and corner shops. Cinemas closed as television and later video held sway at home, a trend not reversed until the 1990s.

The picture above shows the rather tranquil road with trees in the reservation linking the original High Street to Corporation Street on Saturday, 6 June 1970. Cars could still park outside the Ritz cinema, from the roof of which Reg Bull took this picture.

Today some of the houses have gone, the trees have gone and the road is Roanne Ringway. In the distance now is the marvellous Millennium Fountain.

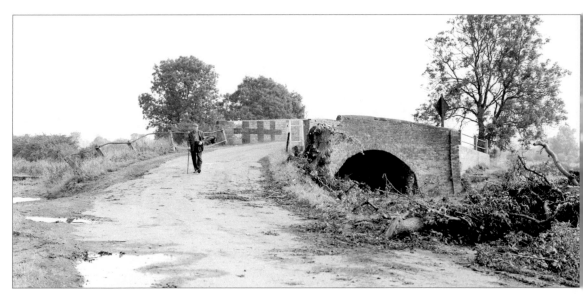

Gipsy Lane is a busy twisting road linking Griff to Whitestone. In 1970 it was still a fairly quiet country road, but already the old bridge over the canal was proving to be inadequate for the traffic using it. Some trees have already been felled in preparation for the replacement bridge, which is wider, flat and without a bend either side of the canal. To walk in the middle of the road, as the figure in the photograph was able to do on Sunday, 23 August 1970, would be hazardous indeed today. *(3745)*

The old Chilvers Coton Workhouse, euphemistically called the College for the Poor by the Victorians (hence College Street), Sunday, 6 September 1970. Built by prisoners from the French wars in 1800, it was a grim building. Behind it the emergency hospital was built during the Second World War, and the workhouse site itself now has hospital buildings on it. Demolition of the building took place in March 1971. *(3758)*

The Chilvers Coton area saw massive changes in the early 1970s, all in the interest of traffic flow. Both pictures on this page were taken on Sunday, 11 April 1971. Above is the view from Avenue Road looking through the arch to the corner of Bridge Street and Coton Road. Pickering's shop is empty, and the whole line of properties between Bridge Street and Edward Street was to be demolished. The picture on the right shows part of the line. Kearn's baby shop, Wood's pram shop and Joy's hairdressing salon are all empty. On the extreme right is the Methodist church, which now lies across the corner of Edward Street and Coton Road. Even the Methodist Church has now closed.
(top: 3791; right: 3795)

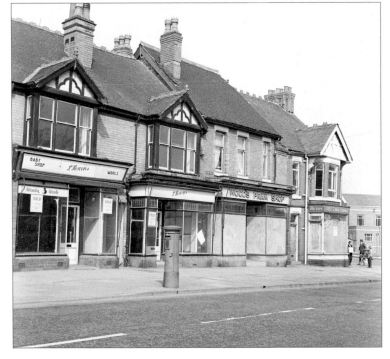

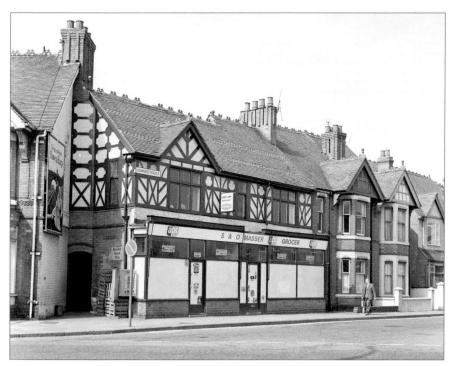

The corner of Coton Road and Edward Street, April 1971. Masser's grocery shop is to be demolished. Reflected in the shop windows is the Methodist church on the opposite side of the road. *(3794)*

Arthur Street seen from the corner of Bridge Street, Saturday, 25 March 1972. The entire street was soon to be demolished, as was the Jolly Colliers pub, just visible in the distance on College Street. Councillor Dickens, ex-mayor, lived in the first house in Arthur Street. *(3996)*

The view from Avenue Road towards Bridge Street, Sunday, 21 January 1973. The property shown on page 83 has gone and Coton Liberal Club is revealed. *(4198)*

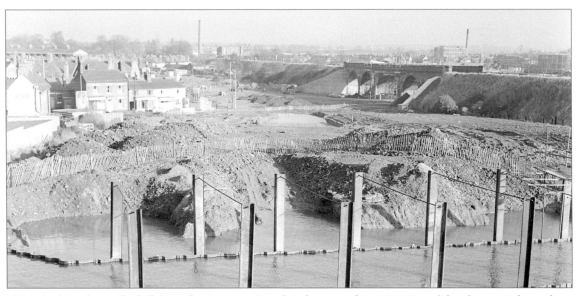

This is looking down the hill from the Coventry Canal and gives a dramatic view of the changes taking place, including the amount of property demolished so that the new road could be built. In the foreground are the foundations for the new bridge over the canal. The picture was taken on Saturday, 8 December 1973. *(4660)*

The new dual carriageway from the M6 was not to finish at Coton Arches but was pushed through to the town centre. This meant that many houses in Coton Road were demolished, particularly those backing onto Riversley Park. This opened up the park in a pleasing way. All the houses shown here in Coton Road on Wednesday, 9 February 1972 were to be demolished. *(3915)*

One year later, on Sunday, 18 February 1973, Reg Bull took this picture a bit further up Coton Road as the road-widening was progressing. The picture shows St Joseph's RC School, with the Catholic church behind it. The school was soon to be demolished and rebuilt behind the church. *(4237)*

Another year later, on Tuesday, 16 April 1974, Reg Bull took this picture of the progress being made on the new Coton Road. The property shown on page 86 has all gone and work is continuing on the new carriageway while traffic is using the old one. *(4737)*

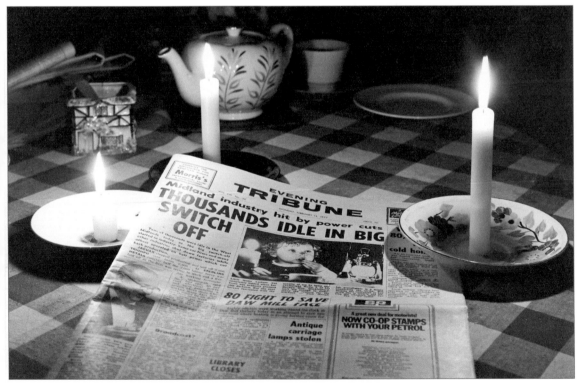

During early 1972 the miners' strike brought disruption to all our lives. Factories were reduced to three- and four-day working and domestic electricity supplies were cut on a planned basis. Candle sales rocketed, and disruption to petrol supplies produced bumper business for cycle shops. Reg Bull set up his camera to photograph the *Evening Tribune* headline for Valentine's Day 1972, though he actually took the picture on Friday, 18 February. *(3931)*

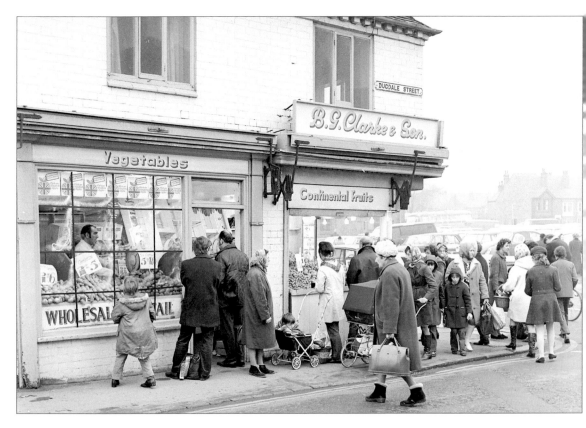

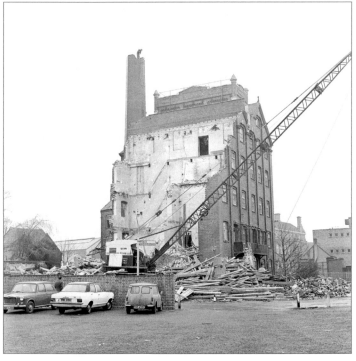

A winter's day, Saturday, 16 December 1972. Reg Bull photographed this building on the corner of Dugdale Street and Queens Road, then used by B.G. Clarke and Son, greengrocer. Jeff Clarke, who ran a greengrocery market stall for many years, is a cousin of B.G. Clarke. The property also still exists. In 1972 carrots were 5p for 2lb. *(4150)*

One of the biggest landmarks in Nuneaton is being demolished here. There had been a mill of some sort here for a thousand years. This one dated from the 1886 and was a solidly built blue brick structure. Its size can be judged against the town hall, which is just visible behind it. The DSS building replaced it. This picture was taken on Saturday, 24 March 1973. *(4308)*

A remnant from an earlier era of shops. Alan Childs ran this little cycle shop in Newdigate Street but was soon to relocate as the site was redeveloped. The picture was taken on Sunday, 15 July 1973. *(4470)*

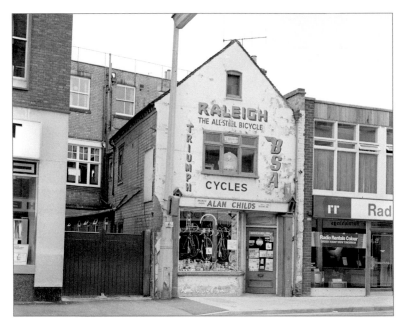

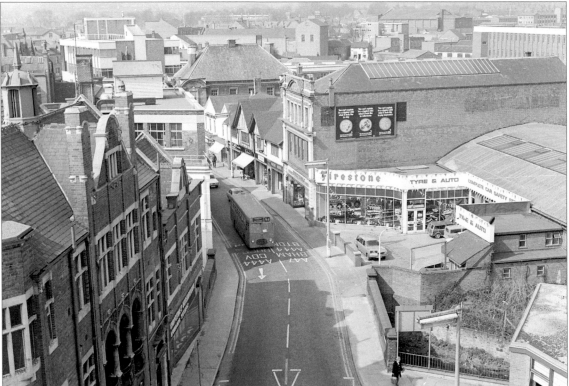

Reg Bull took this picture on Tuesday, 9 April 1974, from the top of the nearly completed Blackburn House in Bond Gate. The Parkside Garage and Parsons, Sherwin & Co. were soon to disappear. St George's Hall and the Conservative Club on the left underwent restoration in 2003, where perhaps in earlier decades they would have been candidates for demolition. Their future is uncertain in 2016. *(4721)*

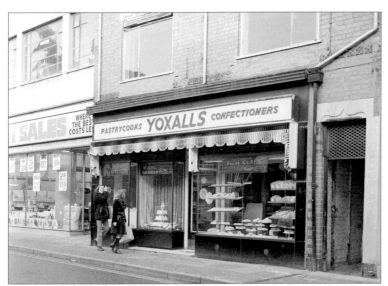

Yoxalls has been in Nuneaton for many decades. The shop here was in Abbey Street. Next to it was Unit Sales, a local DIY and decorating supplies shop that opened many branches in the area and marketed itself aggressively and successfully before being taken over by a bigger organisation.

The picture was taken on Monday, 10 December 1973. *(4667)*

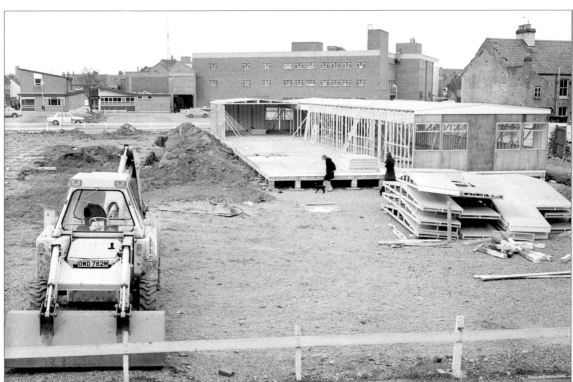

The Dugdale Street and Prince's Street corner on Sunday, 17 March 1974. Houses have been cleared from this area to make way for Roanne Ringway and car parks. Meanwhile, there was local government reorganisation, which made one borough council out of two independent ones. Nuneaton Borough Council and Bedworth Urban District Council were forced into a shotgun marriage and a union called Nuneaton Borough Council. Bedworth people resented the loss of their name and a campaign restored it to the renamed Nuneaton and Bedworth Borough Council. Whatever it was called, there were logistical problems of housing employees, and the picture shows temporary huts being constructed for council officers. *(4670)*

Middlemarch House is an interesting building, giving an appearance of antiquity. In fact it was a carefully built 1930s structure using some old timber for its frontage. Parsons, Sherwin was also a fine, confident-looking building. It was a large hardware and builders' merchants. In the 1970s most towns had similar businesses, but they are rarely seen today. It, and the garage next door, were soon to be demolished. The replacement is of no particular architectural merit. *(4957)*

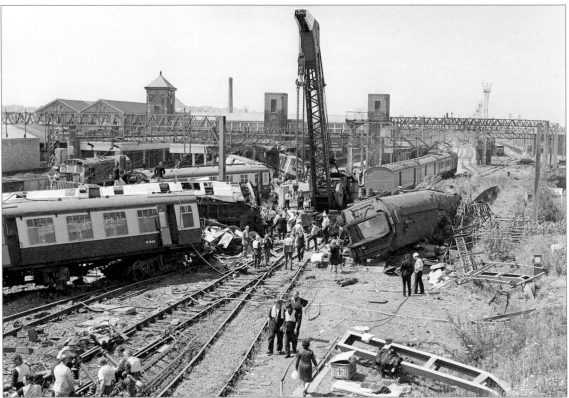

Nuneaton was briefly on the front page of the national press, but for tragic reasons, when there was a serious rail crash with fatalities close to the station and the Leicester Road bridge. Reg Bull took this picture on Friday, 6 June 1975, the day of the crash. *(5058)*

Reg Bull took the picture above of the site of the demolished George Eliot Billiard Hall (see page 49) on Sunday, 30 May 1976. He was standing in front of the Council House (now called the Town Hall). Four years later, in April 1980, he returned to take the picture below of the new, interesting design for Lloyds Bank. *(top: 5269; bottom: 6250)*

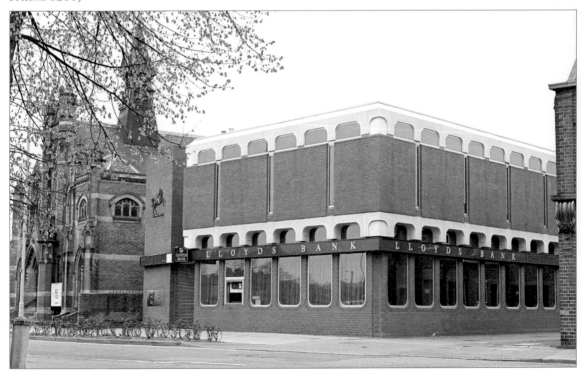

Nuneaton has had a mixed view about its river in recent years. It seems to have been ignored when the George Eliot Gardens were planned. But the Jubilee Bridge in 2002 did much to alter that. In Riversley Park there used to be pleasure boats, as this picture from Sunday, 2 November 1975 shows, but for twenty-five years little was made of the riverside. It now looks as if serious efforts are to be made to create an attractive waterside environment and to rescue parts of the park that have been gloomy and uninviting. A good start was made in 2003 by opening up the river bank adjacent to the museum. The centenary of the park was in 2007. The new feature, 'The Gold Belt', under the widened Vicarage Street bridge is a promising portent. *(5194)*

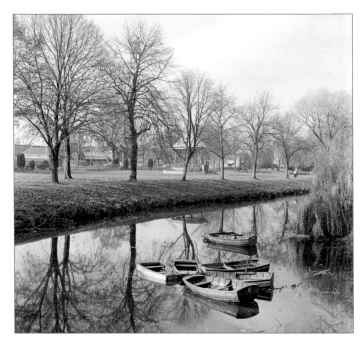

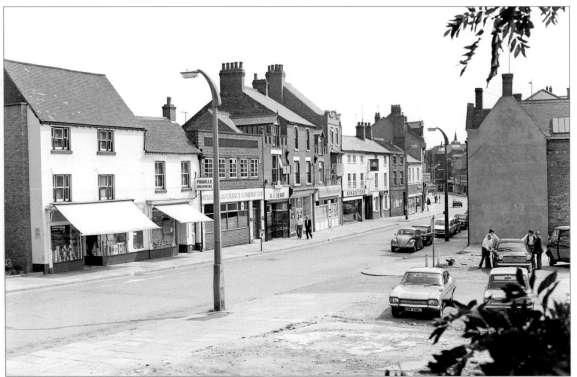

Abbey Street, Sunday, 15 August 1976. The open space on the right was once the site of the *Evening Tribune* printing works. The car with four men about to depart is about where the large candelabra flower feature at the side of The Courtyard (formerly the Bull's Head) pub is. Opposite is Powell's wallpaper shop, now commemorated in Powell Way. *(5376)*

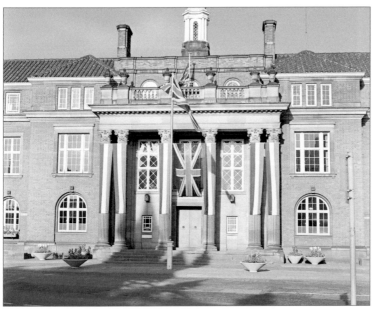

The Council House decorations for the Queen's Silver Jubilee, 1 June 1977: an interesting comparison with the coronation (page 22), but lavish in comparison with the Golden Jubilee. What is very noticeable is the lack of bedding plants, window boxes and hanging baskets in this and other pictures from the time. During the 1990s the borough gained a national reputation for its floral displays and won regular awards at the highest level, only to withdraw in 2002 and 2003, while nearby Coventry discovered what could be done with displays and stole our thunder. The ways of local government are sometimes very strange. *(5478)*

A view from the roof of the Co-op across the old gas works site to Queens Road on Saturday, 18 March 1978. A similar shot now would show Roanne Ringway cutting a swathe across the picture. The shops in Queens Road now finish with Johnson's the jeweller. Maybury's, the Norrland flats and shops and the Palace cinema all went with the coming of the new road. Courtaulds factory in the distance was also to disappear in 1995. *(5672)*

The Norrland flats and Palace cinema, Sunday, 9 April 1978. All this part of Queens Road was soon to be demolished for the new inner ring road. *(5700)*

Changes were not confined to the town centre. Indeed, where industries were closing an entire landscape would change. Brickworks and collieries were notable examples of this in Nuneaton. The pub shown here is the Black Swan in Croft Road. The last landlord was Anthony Abbey and this photograph was taken on Friday, 14 April 1978. *(5702)*

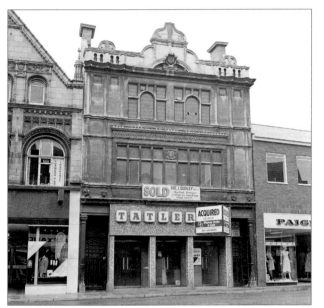

By one of those quirks of fate, there were two good buildings side by side in the Market Place. One, the old Boots shop, had the distinctive terracotta design common to all their early twentieth-century branches. Nuneaton's was built in 1907. The front remains, now protected by Conservation Area status. Next to it the Tatler building, with a very distinctive stone frontage from 1894, was demolished and redeveloped soon after this photograph was taken in July 1978. *(5764)*

Coleman's the fishmonger had already altered its shopfront in Queens Road out of all proportion to the surrounding building, as this picture, taken on Sunday, 7 January 1979, shows. But it was a popular shop which in traditional style used to have wonderful displays of its products. When the site was acquired for redevelopment it moved into nearby Stratford Street, where it continued to trade. *(5830)*

Just before Queens Road enters the Market Place was the Red Lion, a distinguished-looking town pub, rebuilt in the early twentieth century, and now a line of shops. The picture was taken on Friday, 28 July 1978. *(5785)*

Just round the corner from the previous few pictures of Queens Road is Stratford Street. This picture, taken on Sunday, 16 July 1978, shows the building used at that time by the Newdigate Press. The building had once been the Royal cinema in the early 1900s, and before that it was a chapel. Next to it is Smith and Sons, undertakers. When Smith's moved to Avenue Road the site was redeveloped by Wetherspoon's as the Felix Holt pub, and one of the units in the redeveloped Newdigate Press site became Coleman's the fishmonger. *(5759)*

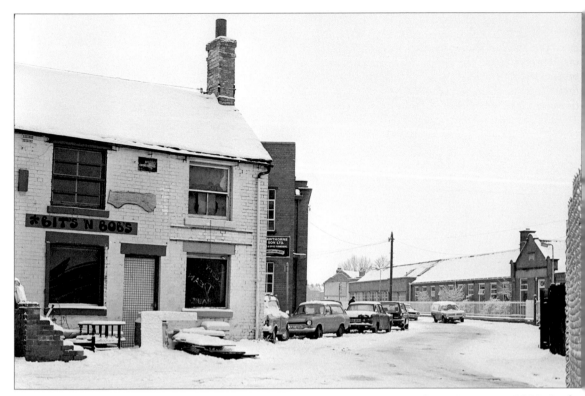

A cold morning in Burgage Place, looking towards Corporation Street, Tuesday, 23 January 1979. In the middle of the picture can be seen the relocated Cawthorne's. The old house selling bits and bobs is closed, awaiting demolition. On the right are the NCB laboratories, soon to be demolished and redeveloped by Halfords, with other commercial units behind. *(5849)*

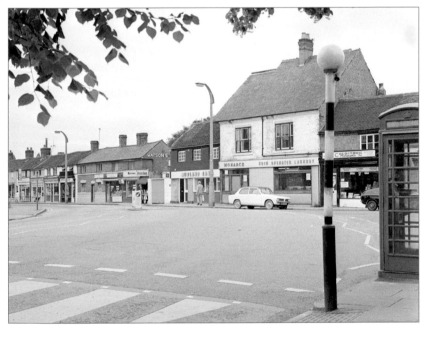

Attleborough Green, looking into Bull Street, Sunday, 16 July 1978. Many banks expanded into suburbs in the 1960s and 1970s, only to retreat from them twenty years later. The Midland Bank in Attleborough was typical. Watson's is still trading in the same shop. At one time there were many launderettes, but as wages rose and washing machines became cheaper they have almost all gone, like the one shown here. Diverting through-traffic had a big impact on Attleborough village. *(5754)*

Still in Attleborough, this time a few years later. Both pictures on this page were taken on Sunday, 18 July 1982. Betty May's was typical of many shops that had carried on this sort of business since the war, but were now finding it increasingly difficult in face of competition from the likes of Mothercare and Adams.

The picture below shows demolition of the Lester and Harris factory in progress. There is now a Co-op store and car park on this site. *(right: 6850; bottom: 6847)*

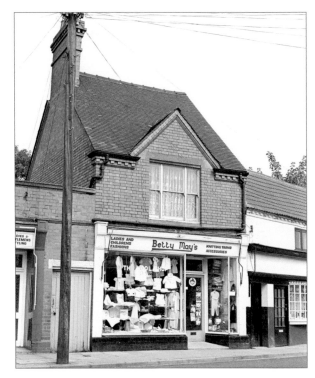

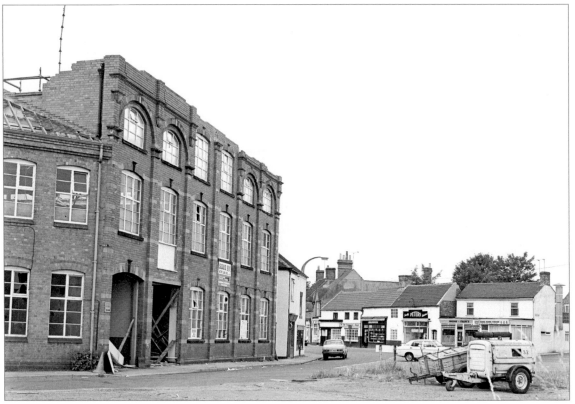

Bermuda village on a snowy Saturday February morning in 1979. Bermuda was built for local miners by the Newdigate estate. There is not a car in sight in this still-isolated little community. *(5874)*

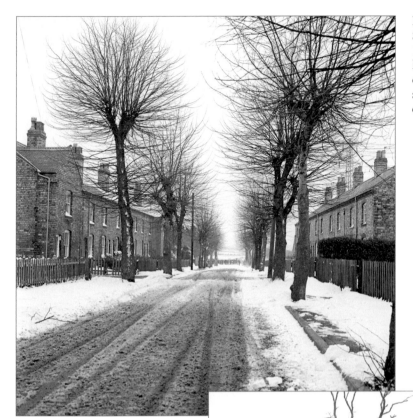

Griff Hollows had featured as Red Deeps in George Eliot's *The Mill on the Floss*. It was an arm of the Coventry Canal serving the local coal mines. Mines closed (when this picture was taken in August 1979 the Newdigate Colliery in Bedworth was the only working mine in the borough and it was to close in February 1982), and the canal arm was not needed.
It was filled in and only a stream remains now. The landscaping done at the time is overgrown and a potential George Eliot attraction is lost. In this picture Hill Top is to the left. *(6034)*

Harris the butchers were at 108 Croft Road. The business had been there since 1947. This picture was taken on Wednesday, 29 August 1979. The business closed on 15 September. Pictured are William Henry (Bill) Harris, Harry Harris, Hilda Harris and William Harris. William died a year later, and Harry died in 1983. *(6071)*

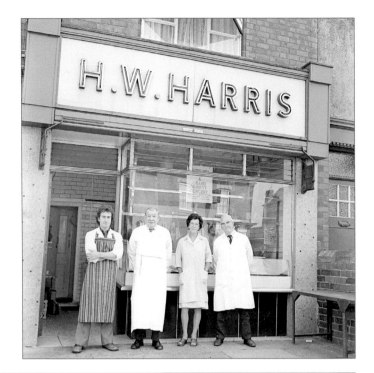

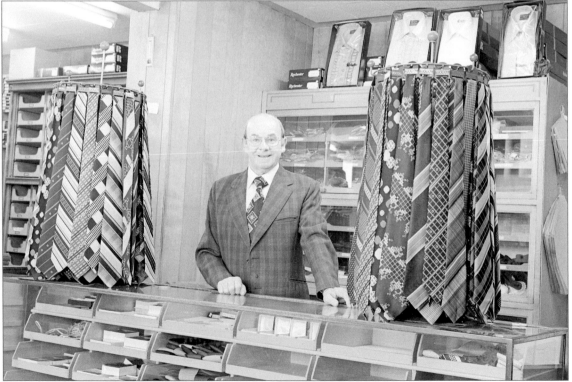

The interior of Fennell's gents' clothing shop, which was to close for business soon after the picture was taken on 4 May 1980, to be taken over by Riley's. Eric Richards had worked for Fennell's since August 1926. *(6258)*

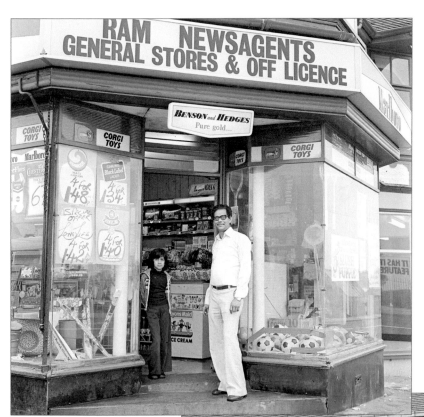

One of the changes in Nuneaton during the last generation has been the arrival and settlement of minority ethnic communities. Many buildings have acquired different uses, including Reg Bull's family house at 159 Edward Street. An early businessman in Nuneaton was Mr Ram, shown here in the doorway to his shop on the corner of Croft Road and Tomkinson Road on Saturday, 20 September 1980. *(6403)*

A picture taken at the end of April 1980. The building is still there in Coventry Street, but all three businesses have changed. NatWest Bank has moved to Bridge Street, and Tustains the solicitors use the offices. Shrigleys, a much respected supplier of quality furnishings, with its original and lovely windows, has gone and a café uses the premises. The *Tribune* closed as a daily evening paper, but the title is retained by Coventry Newspapers, itself part of Mirror Group Newspapers, as a free weekly. The shop is now used by an estate agent. *(6249)*

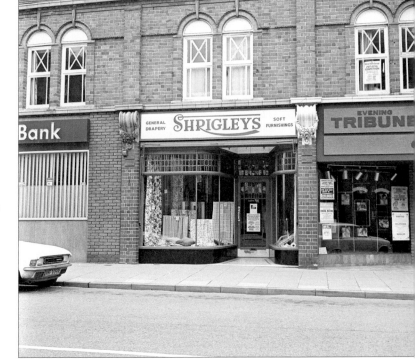

The 1980s saw an enormous shake-up in traditional industries. Listers had moved from Bradford in 1895. They specialised in velvet plush and silk fabrics and moved first to the Albion Works before building the factory shown here in Attleborough Road. Demolition had started when Reg Bull took this photograph in October 1979. *(6170)*

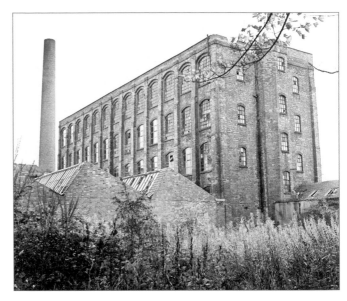

There were sporadic outbreaks of racially motivated trouble in the UK during this period. In Nuneaton relations have generally been good, but this picture tells a story of a response from the Nuneaton Committee against Racism and Fascism to threats from groups wishing to stir up conflict. Reg Bull took this picture from his house on the corner of Frank Street on Sunday, 28 September 1980. It was an unsettled time nationally. The first Thatcher government seemed prepared to see unemployment rise and it was the time of the Toxteth riots. There were 400 marchers here, accompanied by 100 police officers. *(6420)*

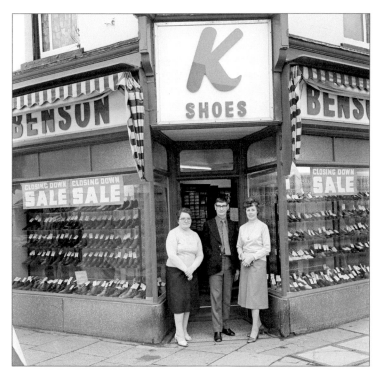

Benson's shoe shop on the corner of Stratford Street and Queens Road, Saturday, 25 April 1981. The shop was closing as the lease had expired. Mrs Joan Greenway (left) had worked there for seventeen years, manager John Finnerty for eight years and Mrs Ella Harding for sixteen years. *(6457)*

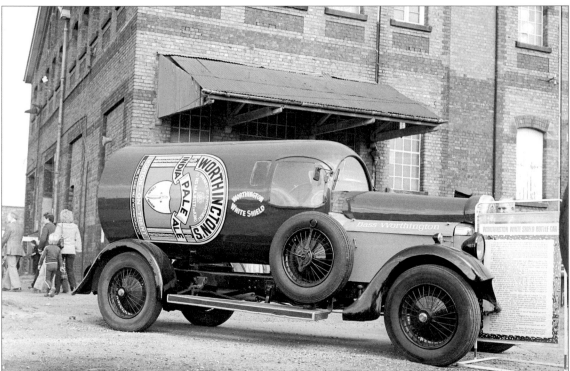

Worthington's bottle car in front of the Nuneaton station railway warehouse (which was demolished in 1985) during a Trent Valley station open day, Sunday, 4 May 1980. *(6266)*

We now expect to see the Christmas tree in the Market Place, but that was not possible when traffic still used the town centre. This snow scene was photographed on Sunday, 20 December 1981, and the tree was placed in Coton Road. *(6592)*

Ernest Pitcher was the owner of Holden's stonemason business in Leicester Road. He was working on a gravestone when Reg Bull photographed him in June 1982. He had come to Nuneaton in 1953 to work for
Mr Holden and bought the business from him in 1963. He died in 1985. *(6768)*

Most buildings in the centre of the picture (taken in May 1982) were about to disappear for the final stage of the inner ring road, which seems to have been going on since 1959. Roanne Ringway was taking shape through 1982 and 1983. The picture below shows where houses and streets have disappeared and the new road is pushing through, with the temporary Leisure and Recreation offices of the council in among it all. The Coton Road roundabout is in the distance. This picture was taken in February 1983. *(top: 6736; bottom: 6952)*

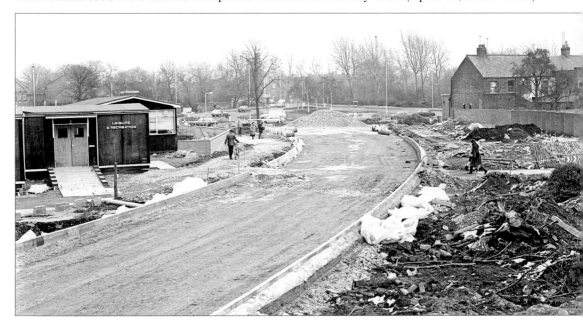

The town side of the Leicester Road bridge. Above is a property awaiting demolition on the corner of Vicarage Street. The business had traded in 1930 as a garage – Atkins Engineering Co. Further down the road on the corner of Bond Gate and Leicester Road was the garage of Sam Robbins. Part of it, the single-storey section, is still there, though not as a garage. Behind it is now the Kwik-Fit garage. Both pictures were taken on Sunday, 5 June 1983. *(top: 7004; bottom: 7006)*

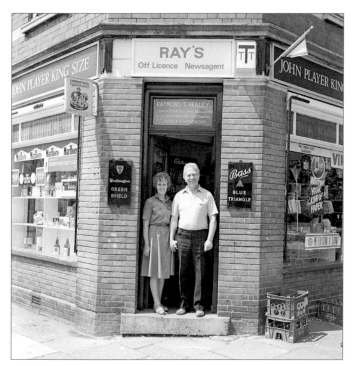

Ray Healey and his wife Lona in the doorway of their shop on the last day of business, Sunday, 3 July 1983. They had come to the shop on the corner of Bracebridge Street and Princes Avenue in 1966. *(7052)*

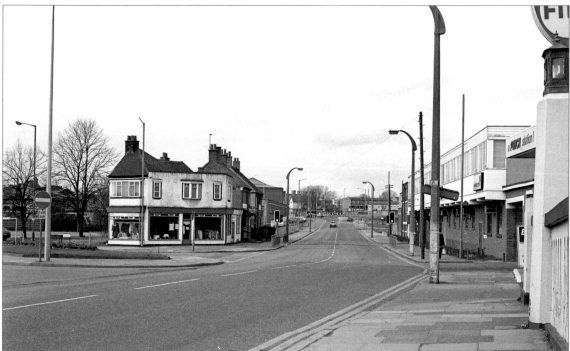

Everything changes, even in twenty years. Newtown Road, by the entrance to the bus station on 1 April 1984. The petrol station on the right has gone. Beyond it Biddle's factory has gone and is now the Asda complex. On the left the property, an early charity shop for Mind, is about to close to make way for the multi-storey car park. On the roundabout in the distance is now the Millennium Fountain. *(7239)*

Biddle's factory in Newtown Road, taken from the entrance to the bus station on Sunday, 17 March 1985. The factory has closed and is awaiting demolition. Reg Bull did not record the building of the multi-storey car park but he took the picture below from the top of it on Monday, 13 October 1986. By then the Biddle's site and the railway sidings had been cleared, and building is under way. *(right: 7407; bottom: 7619)*

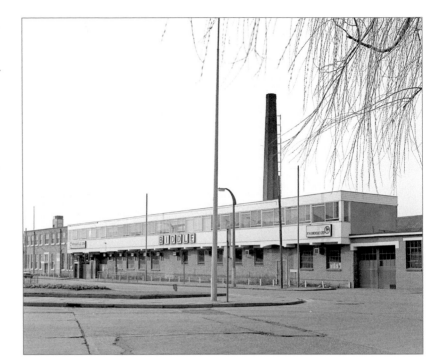

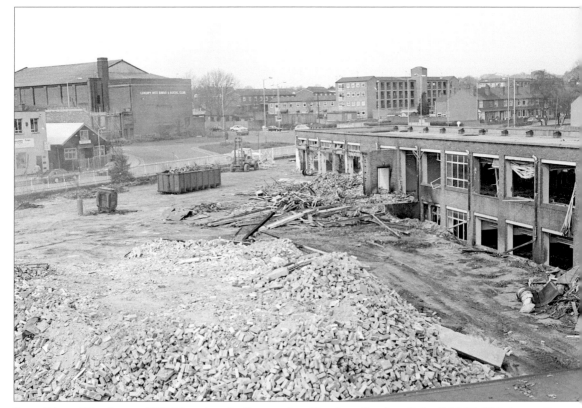

Demolition of the former NCB laboratory in Corporation Street on Sunday, 9 April 1989. This large site was redeveloped by Halfords, who now have a prime view of the Millennium Fountain on the roundabout. The big building on the left was the Ritz cinema, latterly occupied by Gala Bingo but is now empty and sad. *(7729)*

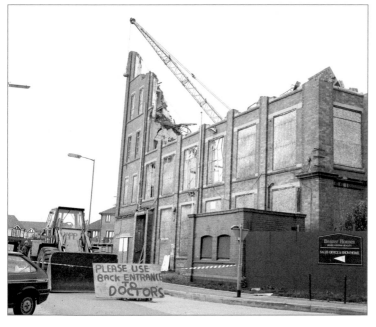

One of Reg Bull's last photographs, of the once-magnificent Courtaulds factory. Beazer Homes already had a sales office and show house and the site now has many dwellings, which is good for town regeneration.

The clock was saved for restoration and Beazer contributed money to the Chilvers Coton Heritage Centre, and has enhanced the restoration of that building for future Nuneaton residents.

The picture was taken on 19 October 1995. *(8025)*

4 Landscape

(3271)

As readers will have gathered, Reg Bull spent a lot of his time recording the changing face of Nuneaton. But he did have a side to his photographic character that appreciated an artistic approach. He loved taking pictures in the snow, and he took many country scenes on day trips outside Nuneaton. This short section pulls together a few local views.

The picture above was taken in Riversley Park on Sunday, 9 February 1969, and shows the little tea rooms that used to be near the present Clinic Drive and the war memorial.

Just before Christmas, on 17 December 1950, Reg Bull had visited Griff Hollows, in the days when few had cars and it was quite a walk to Bedworth. The picture above shows a solitary car making its way from Hill Top to Griff, and the picture below shows the original bridge over the canal at Griff Hollows. *(top: 0055; bottom: 0053)*

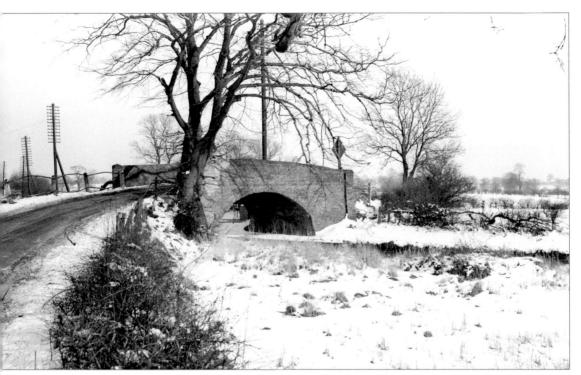

This picture was taken in January 1955 and shows the canal bridge in Gipsy Lane. Reg Bull took it because it made a pleasing image. In 1970 he photographed it again (page 82), but with the purpose of recording a bridge that was about to be demolished. Nevertheless, Reg was always conscious of good composition, whatever the subject, and so the picture on page 82 is all the better for the figure walking over the bridge. *(0523)*

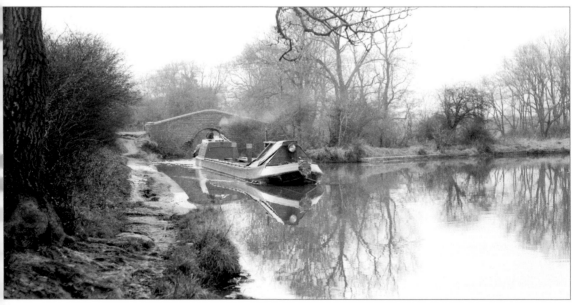

This is a superb photograph taken on 28 February 1957 of a working narrowboat on the Coventry Canal near Griff Hollows. Lady Bridge is in the background. *(0710)*

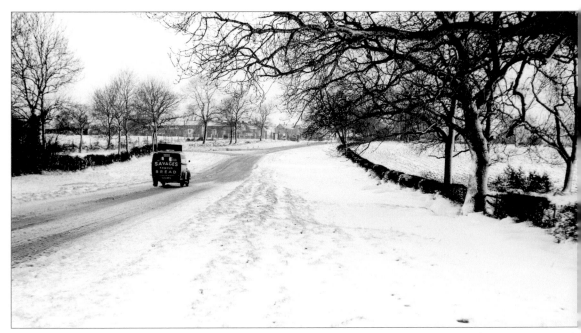

A cold, bleak scene at Bramcote. The delivery van is struggling on the road back to Nuneaton. Gamecock Barracks are on the left of the picture, which was taken in February 1958. *(0811)*

A marvellous image where Reg Bull combines an artistic eye for a picture with factual record. It shows Seeswood Pool at the end of September 1959. It had been a long, hot summer and reservoirs had nearly dried up. Reg positioned himself to record the low level of the lake, but turns a record into a lovely picture of lads fishing. His notes record that it had fallen to only 4 feet deep, and listed which other years had seen low levels, including 1926, 1936 and 1955. *(0980)*

5 Leisure Activities

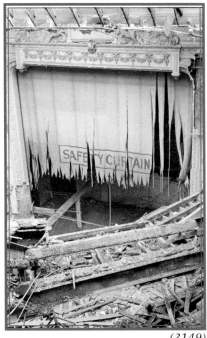

(3149)

Reg Bull recorded some of the town's leisure activities, including sport – football, rugby and cricket. He frequently recorded the town's carnivals, especially when the route passed his house, and especially if an NCB float was involved. He loved cinemas and theatres and recorded all of them in Nuneaton, especially as they were closing. Here is a selection of his interests. The picture above has a great poignancy: it is the tattered curtain that does it! It shows the Hippodrome in Bond Gate after it had closed. Many stars had appeared there since it had opened in 1900. In its last years it was used as a cinema and the films were projected from behind the screen. The picture above was taken on Saturday, 14 September 1968, and Reg probably risked life and limb climbing up to the circle to take it.

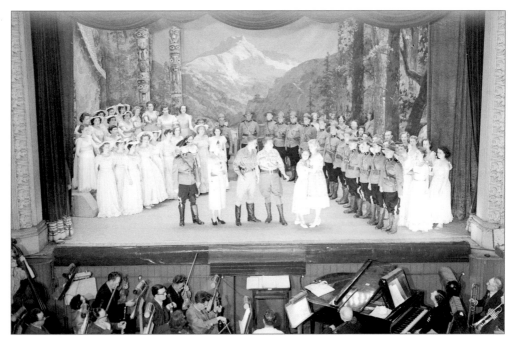

Reg Bull was often asked to produce publicity photographs for local amateur dramatic and operatic groups. The picture above was taken in 1953 for the Nuneaton Operatic Society's production at the Hippodrome of *Maid of the Mountains*. *(box 12-005)*

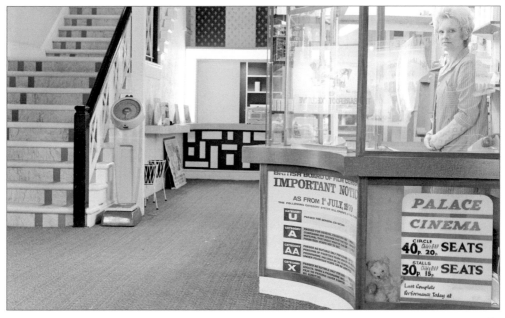

The nearest cinema to Reg Bull's home was the Palace and he took many pictures of it, especially as it reached the end of its life. Never a high-ranking cinema, it struggled to keep up with changing fashions, as this picture shows with its superficial 1960s modernisation. The picture of the foyer was taken on 27 May 1971. Children could still get a seat in the stalls for 15p and the best seats in the circle were 40p. *(3828)*

The Palace cinema in Queens Road was eventually demolished to make way for the Roanne Ringway, but it still had a few years ahead of it when Reg Bull took this picture of the interior at the end of January 1972. *(3879)*

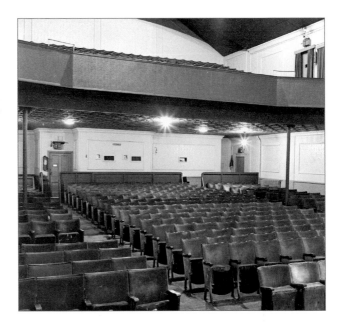

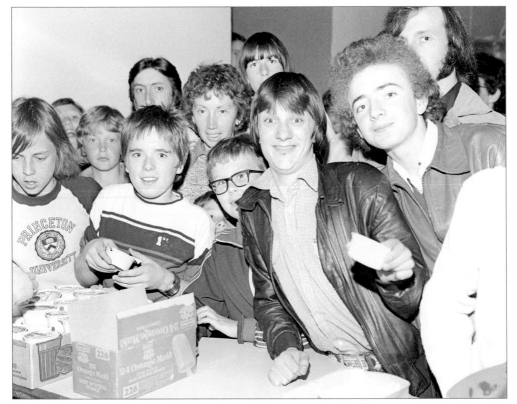

The Palace cinema opened in 1929 and served the community for fifty years. The last film to be shown was *Moonraker*, and the manager at the time was Fred Gambrill. Reg Bull photographed these youngsters at the ice-cream counter at the last performance on Saturday, 15 September 1979. *(6121)*

The Scala in Abbey Street was a rather more opulent cinema than the Palace, although they tried to modernise the foyer with a 1960s-style clean-lined box office and counter. The picture here shows the 1914 building with its theatrical tradition of circle and elaborate plaster work. The picture dates from 18 February 1972. Reg Bull returned to the Scala several times over the next few years, and the picture below shows the building when it had been gutted. The circle and the foyer have gone, but at least the fine exterior remains today. It seems incongruous to see a JCB inside a cinema. The picture was taken on Sunday 15 June 1980. *(top: 3921; bottom: 6311)*

There is something of a mystery with the two pictures here. Very unusually for Reg Bull, there is little information recorded about them. The picture above dates from 1952 or 1953 and shows two uniformed taxi drivers with their taxis, waiting outside Chilvers Coton parish church in Avenue Road. There is a name on their caps but it is too indistinct to read. There are flags on both vehicles. Could it have been Coronation time? Information would be welcome.

The picture below is of one of Lloyd's coaches, taken at Arley, again about 1952. Was it a trip out? A works bus? The background seems to refute that, and who is the driver? Reg Bull normally provided all this information. On an occasion when he doesn't, it makes us appreciate all the times when he does! Lloyd's bus depot was in Avenue Road, and it can be seen in the top corner of the aerial photograph on page 43. *(top: box 12-051; bottom: box 12-052)*

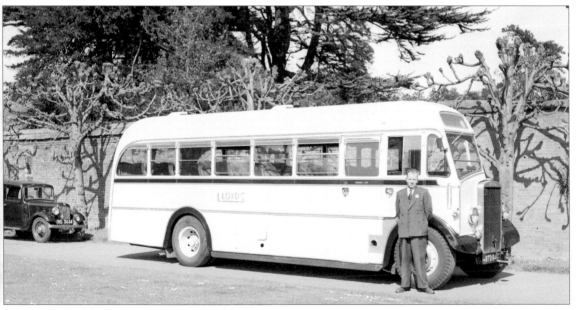

Reg Bull has recorded little detail about this picture. Was he there for a wedding reception? Clearly it was a special occasion with a buffet at the Newdegate Arms Hotel. Presumably the manager and manageress are there, with two waitresses. The date was 27 February 1958 and any more details would be welcome. *(box 12-179)*

The first Palm Sunday procession from the Edward Street Mission (now a Muslim Day Centre) to Chilvers Coton Church in 1978. On the left is the vicar, the Revd Colin Henderson, behind the donkey is the curate, the Revd Tony Darby, and on the donkey is Colin Brown. *(5688)*

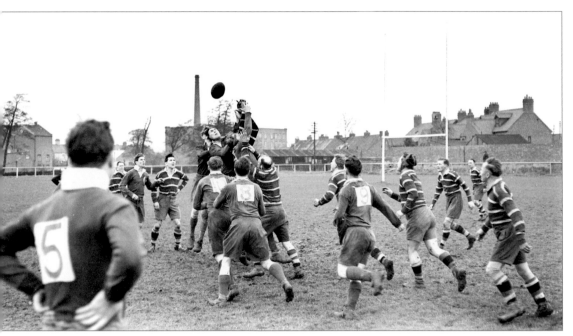

eg Bull took a lot of photographs of Nuneaton RFC in the 1950s, but few after that. He turned then to uneaton Borough AFC in the 1960s. The picture above shows action in a line-out in the match between uneaton and Saracens, which Nuneaton won 9–3, at the New Inn Ground at Attleborough on Saturday, April 1951. The picture below shows the ground three days after the last match was played there on aturday, 11 November 1995 against Birmingham Solihull (16–14). It ended seventy-seven years at the round. The contractors moved in and there is now housing on the site, while the rugby ground has moved to astboro Way. *(top: 0066; bottom: 8041)*

The photograph above shows Nuneaton Borough's football ground at Manor Park. There is always work t
do on a pitch, and manager Fred Badham is being helped by some lads. The picture below was taken by Re
Bull on Monday, 25 October 1965. It shows the first goal to be scored under the new floodlights at Manor Par
in a friendly against Leicester. Goalkeeper Shilton was beaten by a shot from Nuneaton centre-forward Bi
Atkinson. The attendance at the match was 6,250. *(top: 1278; bottom: 2134)*

Not a normal day outside Woolworths, it has to be admitted, but it was common practice for a circus to announce its presence by walking its elephants from the station to the big top. This was Sir Robert Fossett's circus on Sunday, 5 May 1974. *(4476)*

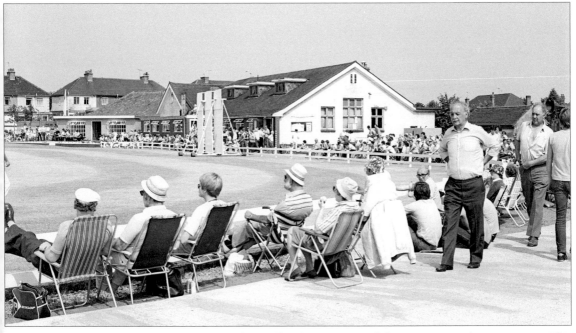

Warwickshire CCC used to venture as far as the Griff and Coton ground for an occasional county game. This one was the second day of a game against Essex on Monday, 11 July 1983. *(7056)*

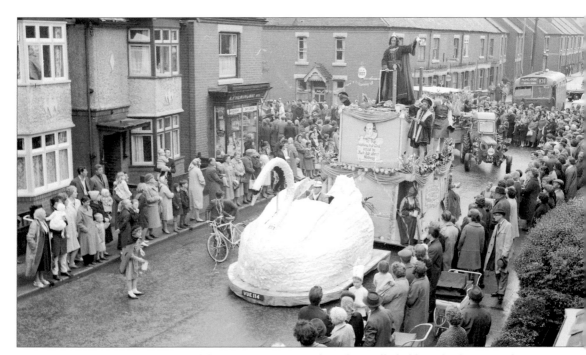

Reg Bull's home was on the route of the Nuneaton Carnival, traditionally held on the first Saturday in June. In the 1960s there were large numbers of floats, and spectators lined the streets. Most carnivals have lost some of their popularity, as tastes have changed and the motor car takes us to other entertainment. Reg paid particular attention to floats entered by NCB groups. The picture above from 1964 shows the swan float entered by the NCB at Haunchwood. The picture below shows the Haunchwood float in 1965. It was on the theme of 'It's Magic'. Both pictures were taken in Edward Street. *(top: 1762; bottom: 2077)*

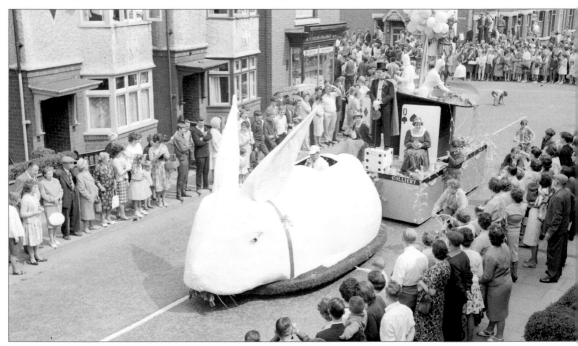

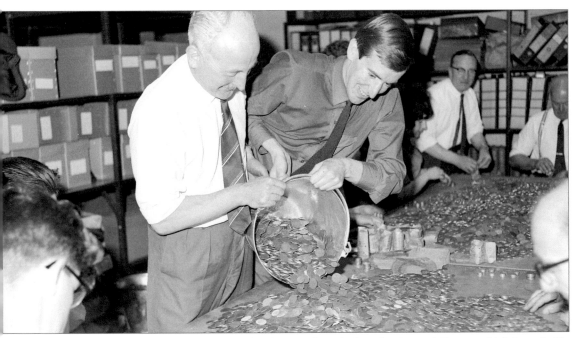

Behind the scenes after the carnival. Reg Bull's brother Cyril worked at the Council House, which is probably how Reg was able to take this picture of money being counted by the Borough Treasurer's staff in the Council House basement (Tom Burgoyne is on the left) on Wednesday, 9 June 1965.

The picture below shows Biddle's float in 1968. The interest is in the topical references that carnivals sometimes have. The late 1960s were exciting times for space exploration and the first manned landing on the moon. That interest is reflected in Biddle's 'Luna Heating' float. *(top: 2090; bottom: 2976)*

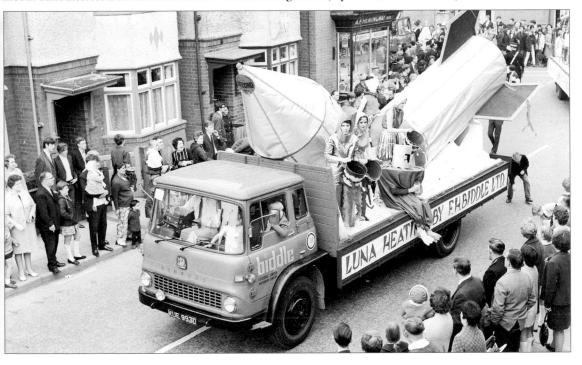

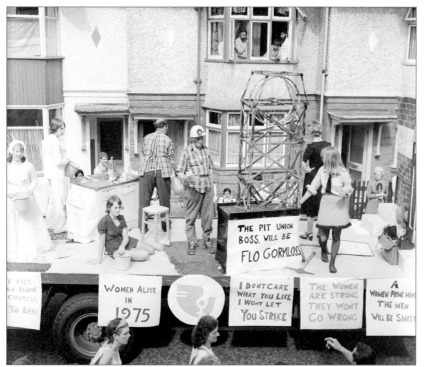

The early 1970s saw a lot of industrial conflict, especially in the mining communities. This float from 1975 reflects some of the tensions from that time, with references to Joe Gormley, the miners' leader, and interesting comments on women in a strained society. The picture below shows the carnival procession in June 1980. It rained. Carnival Queen Diane Holmes and her maids of honour try to keep smiling under their umbrellas.
(left: 5088; bottom: 6285)

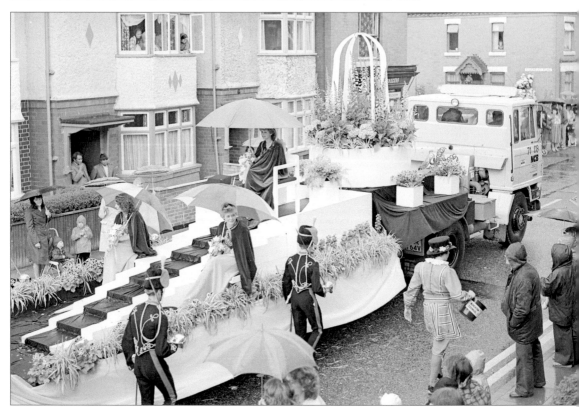

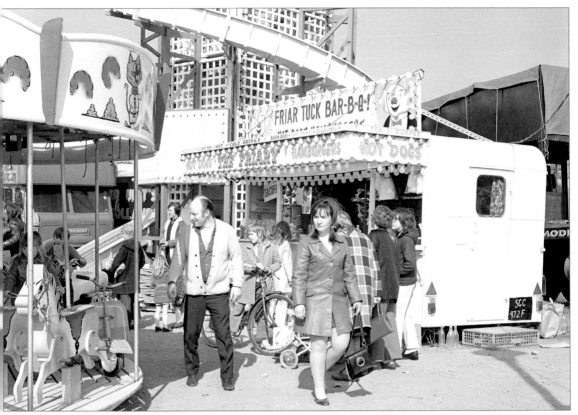

Barker's Spring Fair at the Pingles on Sunday, 15 April 1973. Many fairs date back many years, but are updated with the latest entertainment to draw the crowds. Nuneaton's Spring Fair is hundreds of years old, and in earlier years brought a welcome bit of excitement to ordinary people. *(4350)*

The Nuneaton Detachment of the Royal Warwickshire Regiment, known locally as the Drill Hall, when it was being virtually rebuilt and converted to be an arts centre in December 1972. In recent years money and effort has created a thriving venue for amateur theatre. Renamed The Abbey Theatre, it has a variety of productions and is home to Simon Winterman's Impulse Theatre Company, which produces theatre of extraordinary quality. *(4144)*

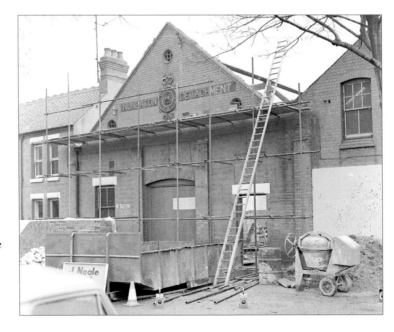

WARWICKSHIRE COUNTY RECORD OFFICE

Unique historical resources available to everyone

Warwickshire's history, Warwickshire's memory

The County Record Office is a service to the community and to all those interested in the history of the county of Warwickshire.
We hold a vast and varied collection of material covering 900 years of the history of Warwickshire and its people.
We are still collecting records for future generations.

Warwickshire County Record Office
Priory Park, Cape Road, Warwick, CV34 4JS
Tel: 01926 738959 Fax: 01926 738969
Email: recordoffice@warwickshire.gov.uk
www.warwickshire.gov.uk/countyrecordoffice